SECRET
PINNER

Thamar MacIver for
Pinner Local History Society

AMBERLEY

Acknowledgements

Contemporary photographs are largely my own. All other illustrations are from private collections, whose owners include Pinner Local History Society, Pat Clarke and myself, and others who prefer not to be named, as well as Bernard Harrison (p. 8a), Ken Kirkman (p. 47a), Frank Palmer (p. 86), Hilary Thornley (pp. 44, 87), and the William Heath Robinson Trust (p. 8b). We are grateful to all who have allowed us to use their pictures.

Every attempt has been made to seek permission for copyright material used in this book. However, if we have inadvertently used copyright material without permission/ acknowledgement we apologise and we will make the necessary correction at the first opportunity.

First published 2018

Amberley Publishing
The Hill, Stroud
Gloucestershire, GL5 4EP

www.amberley-books.com

Copyright © Pinner Local History Society, 2018

The right of Pinner Local History Society to be identified as the Author of this work has been asserted in accordance with the Copyrights, Designs and Patents Act 1988.

ISBN 978 1 4456 7979 2 (print)
ISBN 978 1 4456 7980 8 (ebook)

British Library Cataloguing in Publication Data.
A catalogue record for this book is available from the British Library.

Origination by Amberley Publishing.
Printed in Great Britain.

Contents

Introduction

Nowadays comparatively few of Pinner's residents have grown up locally. They may not know much about Pinner's past and may not recognise, or understand, the traces it has left in the place they know. Even those who have been here a long time may find some details and stories come as a surprise, and I hope there are many surprises to be found in this book.

Until the railways came, Pinner was a very small agricultural community off the beaten track. It was startlingly self-sufficient – in food, policing, even firefighting, for example. Despite this, it was touched by national events and changed greatly over the centuries. Pinner is surprisingly rich in evidence of these early years.

The railways transformed Pinner: gradually from the 1840s when the station we know as Hatch End opened, faster after the Metropolitan Railway opened its Pinner station, and faster still from around 1930. The railways brought Pinner some remarkable buildings and many interesting people, while many others have been born here.

This book covers a much wider area than readers might expect, taking in Pinner Green, Hatch End, North Harrow, Headstone, and much of Rayners Lane. All these places are within the historic parish of Pinner, which remained the area covered by Pinner Parish Council until 1934, when it became part of Harrow Urban District (now the London Borough of Harrow). Pinner was part of Middlesex, which is now entirely within Greater London, but until around a hundred years ago it was outside the metropolis and very different from it.

Chapters are designed to be read in any order and appear in a haphazard sequence, intended to encourage 'dipping'. If you prefer a chronological approach, The Middle Ages covers Pinner's beginnings. Most other chapters span the centuries, though Famous People and The Arts are largely about the 1800s and 1900s, while Suffragettes and Becoming a Suburb relate to the twentieth century.

It would have been impossible to write this book but for research carried out over the years by members of the Pinner Local History Society and above all by Pat Clarke and the late Jim Golland. We all also owe a great debt to long-term residents and descendants of residents who during the society's existence have shared with us their memories, photographs and artefacts. Any reader whose interest is sparked and who would like to know more should get in touch with (or, better still, join) the society. I am also immeasurably grateful to the research group, and particularly to Pat again, for their help and support, and to Jo and John Crocker who prepared the map.

Our area is now inhabited by people whose families derive from all over the world and all over the United Kingdom, in that they resemble the vast majority of Pinner's inhabitants over the last 100 years and more, most of whom have been newcomers. This book is about the place where we live; its past belongs to all of us. This is an introduction to the unexpected wealth of that past and I hope you enjoy it.

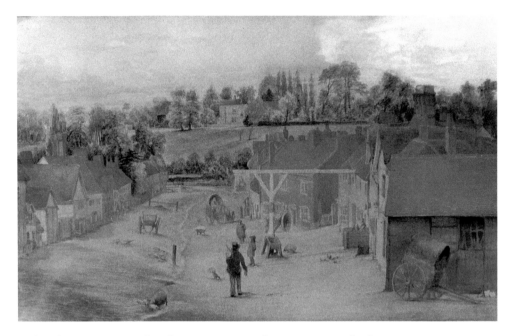

Earliest known painting of High Street, *c.* 1820, with West House in the distance.

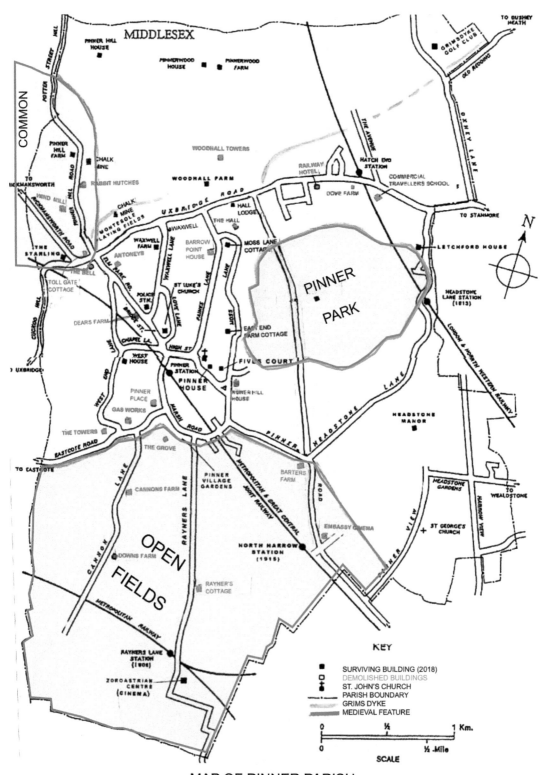

MAP OF PINNER PARISH
Guide to Approximate Locations of Places in Text

1. The Arts

Before around 1920, when artistic people craved the countryside, Pinner was an accessible rural area. More recently it has been a convenient base for those with regular business in London. In consequence, it has hosted a remarkable range of talents. There is space to name only some of the creative people who have lived here. It is striking how many are famed for their humour.

Visual Arts

Surviving treasures hint at artistic taste in Pinner in the 1600s: the fragment of a hunting scene at East End Farm Cottage and the embroidery of Martha Edlin of The Grove, now at the Victoria & Albert Museum. In the 1700s Lady Jane Brydges of Pinner Hill House was painted by Allan Ramsay. Pinner historian Edwin Ware believed a portrait painter named Smart lived near Pinner church and painted local people: there is a delightful oil painting (*c.* 1830) of Albert Pell of Pinner Hill House in boyhood, depicted probably in its woods, by a painter named Smart. This cannot be portraitist John Smart (d. 1811).

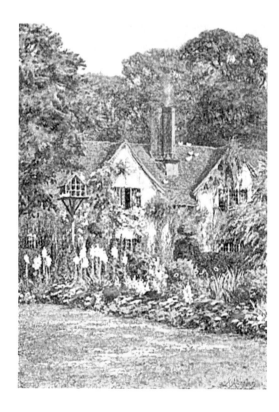

Waxwell Farm by Helen Allingham.

Victorian artists who painted Pinner included Myles Birket Foster, Helen Allingham, and Kate Greenaway.

Louis Davis (1860–1941) lived in Paines Lane from the 1890s. He was an important stained-glass artist, his work influenced by the Pre-Raphaelites and full of colour and movement. Examples are in St Giles' Cathedral, Edinburgh, Dunblane Cathedral, and many churches, including Pinner and Hatch End parish churches. At Hatch End his baptistry window (1915) includes a fragment of ruby glass from Ypres's devastated cathedral and, in tiny letters, the name of 2nd Lieutenant Michael Hill, a former choirboy there, who was killed while Davis was working on the window.

Edwardian residents included Henry Henshall (1856–1928), particularly known for watercolours of simple lives, often featuring the very young and very old.

Horace Mann Livens (1862–1936) lived in Hatch End from around 1912. His work included landscapes (some published as book illustrations), pastels of his household and latterly paintings of chickens. He is remembered today as a friend of Van Gogh; they both studied at Antwerp where Livens painted Van Gogh, who later wrote to Livens outlining his artistic aims. Livens' own life was disrupted by the mental illness that afflicted his wife and children.

Brothers Thomas (1869–1954) and William Heath Robinson (1872–1944) were established illustrators before William added his surname to the language through his drawings of fantastical contraptions. Thomas lived in Love Lane, and William in Hatch End and later in

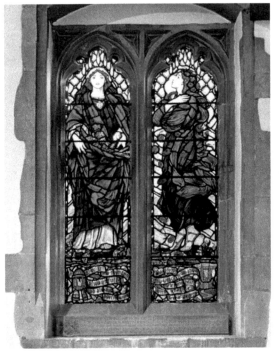
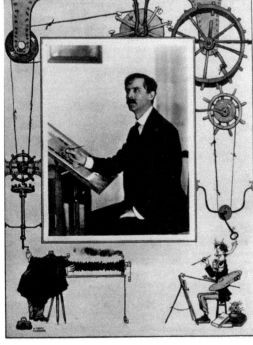

Above left: Louis Davis's Ellen Nugent memorial window, Pinner parish church.

Above right: William Heath Robinson during his time in Pinner, 1915.

By kind permission of London Opinion, August 7th, 1915.

OUTSIDE THE "QUEEN'S HEAD", PINNER, MIDX.

VILLAGE REPROBATE (GAZING AT RECRUITING POSTER) "LAWKS . I NEVER SEE SICH A SENSIBLE INVITATION IN ME LOIFE !"

Bert Thomas First World War cartoon.

Moss Lane in the early 1900s. Pinner's Heath Robinson Museum opened in 2016 to house works related to William, and it has regular exhibitions. The brothers founded the 'Loyal Federation of Frothfinders', and with others including a third brother Charles and cartoonist Bert Thomas, rambled through the local countryside in search of good beer.

Cartoonist Herbert Samuel 'Bert' Thomas (1883–1966) often featured in Punch, with many drawings having a political slant. He also produced propaganda posters during both world wars. He lived at Church Farm (High Street) and is remembered in Pinner for cartoons featuring local landmarks.

In 1923/4 the Whistlers lived at Pinnerwood House. Rex (1905–44), then at the Slade, became an artist and illustrator responsible for murals at Mottisfont, Plas Newydd and the restaurant at Tate Britain; Laurence (1912–2000) was later known for glass engraving, including bowls awarded to Mastermind winners. Laurence recalled how Rex loved the house, drawing it repeatedly in sketchbooks now at Salisbury Museum. They punted on the lake in the garden, with a gramophone on the lawn playing dance music – very 1920s.

Writing

When Pinner became part of the borough of Harrow in 1934 a quill pen was added to the coat of arms to signify Pinner, ostensibly not because of the similarity of 'Pen' and 'Pinner', but because of Pinner's many writers. It is not clear who they had in mind.

One writer who worked here before railways made Pinner readily accessible was the later Lord Edward Bulwer-Lytton (1803–73). He wrote *Eugene Aram* (1832) at Pinnerwood House. He would later inherit Knebworth House through his mother, but she cut off his

Pinnerwood House. Former residents include Lord Lytton and the Whistlers.

allowance when he married against her advice in 1827, so he supported himself by writing popular fiction. *Eugene Aram* was based on the real case of a distinguished philologist hanged in 1759, when found to have committed murder years earlier. Lytton is famous now as the writer of *The Last Days of Pompeii* and the originator of phrases including 'the great unwashed' and 'the pen is mightier than the sword', and the much-mocked opening beginning 'It was a dark and stormy night'. When he was at Pinner, his marriage was in trouble. Eccentric and bi-sexual, Lytton later saw his political career threatened by his wife's vilification of him and had her committed. She was released following a scandal. (Contemporaries thought both parties on the verge of madness; Rosina described herself as 'half-mad'). They were grandparents of suffrage campaigner Lady Constance Lytton.

James Henry Pye (1744–1813) may have been the worst poet ever made Poet Laureate, appointed because of political support for William Pitt the Younger. He lived at East End House.

Novelist Ivy Compton-Burnett (1884–1969) lived in Hatch End until she was two.

A. E. Housman (1859–1936) lived in Devonshire Road, Hatch End, between 1905 and 1911. Famous for *A Shropshire Lad* (1896), he focussed thereafter on his life as a classical scholar, becoming a professor in London and from 1911 in Cambridge. He came here only because his London landlady moved to Hatch End, and took little part in local life, entertaining friends in London restaurants, for example.

Pinner has been the home of several popular writers. 'Rowland Grey' (Kate Lilian Rowland Brown, 1863–1956), of Oxhey Grove, Oxhey Lane, wrote novels popular in the 1890s and co-authored a biography of family friend W. S. Gilbert. Olive Wadsley, who lived in Marsh Road in 1911, wrote *The Flame* and other romantic books filmed between 1918 and 1924. Howard Spring (1889–1965) wrote several bestsellers, and was in East End

Way in the 1930s when writing *Fame is the Spur* (1940), later made into a film starring Michael Redgrave (1947) and a BBC TV series with Tim Piggot-Smith (1982).

Barry Pain (1864–1928) lived here in the 1890s, at Red Cottage in Elm Park Road and then at The Circuits off Cuckoo Hill, with his wife, a sister of Liza Lehmann (*see* below). A prolific writer and journalist, his pieces for *Punch* included the Eliza sketches, later issued in book form and more recently adapted for television and radio. These revolve around Eliza's husband, a fussy, conventional and ambitious man constantly making ill-advised decisions his more intelligent wife has to resolve. There is something touching about him despite his foibles, and he has been compared as a comic creation to Basil Fawlty. Pain also wrote novels and horror stories.

Writer Rebecca West (1892–1983) moved to Royston Park (Hatch End) early in the First World War with her infant son Anthony, born of her ten-year affair with H. G. Wells. At the time she was primarily a journalist, acting as a critic and promoting feminist and left-wing causes. She was not happy there, while Anthony later made it clear he felt neglected as she pursued her professional career. Her *The Return of the Soldier* (1918) has a local setting.

Malcolm Bradbury (1932–2000) lived in Warden Avenue, Rayners Lane, until 1941. He is famous for works including *The History Man* and for founding the creative writing course at the University of East Anglia. His distinguished students include Ian McEwan and Kazuo Ishiguro.

Michael Rosen (b. 1946) describes his childhood in Pinner with Communist teacher parents in his memoir *So They Call You Pisher* – the local branch met in their flat above a Love Lane shop. The different worlds of his childhood (his Jewish relatives, his various local schools, and communist holidays) are evoked in all their oddness. He is famous for humorous books and poems for children.

DID YOU KNOW?

Pinner has two unexpected connections to 1930s literary life. T. S. Eliot's first wife Vivienne (d. 1947) is buried in Pinner Road cemetery. Gerald Brenan (1894–1987), a writer linked to the Bloomsbury Group and best known for works about Spain where he spent much of his life, entered an Uxbridge Road nursing home in 1984. Spanish fans, convinced he was there against his will, 'liberated' him. Spanish authorities made special arrangements for his care, and he died in Spain.

Music

Liza Lehmann (1862–1918), already well known as a singer, spent the first two happy years of her marriage at Pinner. The couple lived from 1898 at Nascot, Waxwell Lane, a cottage with topiaried yews painted by Helen Allingham and Kate Greenaway. There they kept chickens that rarely laid eggs and bees that gave little honey, and Liza wrote her

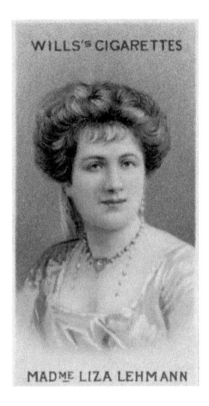

WILLS'S CIGARETTES

MADME LIZA LEHMANN

Cigarette card of Liza Lehmann, c. 1914.

first significant composition, a song-cycle based on the Rubaiyat of Omar Khayyam. She became known for her songs, a regular feature of early Proms, though her longer pieces met with limited success. She ran into their local friend W. S. Gilbert while practising cycling: he said he would have been no more surprised to encounter the Virgin Mary on a bicycle.

Another neighbour and friend was Maude Valerie White (1855–1937), who lived in Love Lane. She too was a professional musician, known today for her setting of Byron's 'So We'll Go No More a Roving', and famous then for her many songs. She also wrote pieces for chamber groups and three operas: Lehmann recalled her excitement over progress with a 'Rumanian opera'.

Horace Mann Livens's son Leo Livens (1896–1990) showed marked early promise and achieved distinction as a musician and composer of pieces that are highly regarded but little played. In 1922, he was appointed Professor of Music at the Royal Academy of Music. Mental instability – possibly bi-polar disorder – blighted his life and performances and compositions dried up.

George Shearing (1919–2011) lived in East Towers from 1941 to 1948 during his first marriage. He would go into London each evening to play through the night at various venues, returning on the first train. In 1948, he went to America, taking his Pinner neighbour Dennis Warren as road manager. Dennis recalled a tour of Canada where at the border office the radio was playing. When Dennis told an official who they were, the official explained that he wanted to know their identities, not who was playing. Dennis

replied happily 'same answer'. It was in America Shearing had his greatest success, including playing before three presidents. His biggest hits were 'September in the Rain' and his own composition 'Lullaby of Birdland'. In his later years he also spent time in England, once playing for the Queen, and was knighted, which he described as 'a fairy-tale come true' for 'the poor blind kid from Battersea'.

Leslie Bricusse (b. 1931), born and educated in Pinner, launched a distinguished career as a writer of humorous songs and much more at the Cambridge Footlights. Shows written by him include *Dr Doolittle*, and, with Anthony Newley, *Stop the World, I Want to Get Off*, *The Roar of the Greasepaint, the Smell of the Crowd*, and *Willi Wonka and the Chocolate Factory*. It was with Newley that he became a member of Radio City's Songwriters' Hall of Fame.

There is no need to introduce Sir Elton John (b. 1947), Pinner's most famous son. He was brought up by his mother in Pinner Hill Road, near the home of his grandparents, and attended Pinner Wood Junior School, Reddiford School and Pinner County. He has spoken of his bemusement at his glittering early successes, happening to 'a boy from Pinner', but if Pinner seemed the reverse of pop glamour, he is not the only pop celebrity with a local connection.

Bruce Welch (b. 1941) of The Shadows lived in Headstone Lane during the 1960s. It was at a party there in 1963 that The Beatles met Cliff Richard, who was impressed when the Beatles played 'From Me to You' before its release. Welch is famous as a song writer for Cliff Richard – his credits include a share in 'Summer Holiday' – and for Olivia Newton-John (to whom he was briefly engaged), and as a producer for Cliff, Olivia and others, including Charlie Dore, herself from the family that once owned Pinner Hill House.

Richard Wright (1943–2008), founder member of Pink Floyd, grew up in a comfortable house in Hatch End, with his father the head bio-chemist at Unigate Dairies. He taught himself the guitar aged twelve while at home with a broken leg. In the 1960s he met other future band members at Regent Street Polytechnic. He became Pink Floyd's keyboardist and sang and wrote songs and, increasingly, instrumental works for the group.

Gordon Waller (1945–2009), famous as part of the duo Peter and Gordon, lived in Pinner in childhood.

Roger Glover (b. 1945), bass guitarist with Deep Purple, lived briefly in Pinner (1960–61) when his parents ran the Oddfellows Arms. He remembers being stunned hearing The Shadows' 'Apache' on the radio there. At Harrow County he formed The Madisons, later forming Episode Six, who rehearsed initially in the Hatch End home of Sheila and Graham Carter-Dimmock. Aged sixteen, he was among lads, singing loudly on Rayners Lane hill, picked up by police and charged with disturbing the peace. He and Ian Gillan left Episode Six for Deep Purple in 1969, and he was with them when they released their most successful albums.

Simon Le Bon (b. 1958), lead singer, lyricist, and recently guitarist for Duran Duran, was brought up in Dawlish Drive and attended both Pinner County and Nower Hill high schools. He had theatrical training and roles before the momentous day when he turned up at an audition to join a band that had found its feet musically but lacked a lead singer, dressed in pink leopard-print trousers and carrying a notebook of his own lyrics, many soon to feature on the band's albums. Within weeks they launched a sensational career.

Film and TV

Ronnie Barker (1929–2005) lived at Elmdene, Church Lane, for many years. His big break was appearing with Ronnie Corbett in *The Frost Report*. After a technical hitch at the BAFTAs, obliged them to entertain assembled notables unscripted, the Two Ronnies were given their own slot. This much-loved and long-running show increasingly used pieces written by Barker. It has been suggested the 'Four Candles' sketch was based on a Pinner ironmonger's, though Barker said the idea came from an actual misunderstanding described by someone who wrote in to the show. When not in character, Barker was very shy, claiming to have tried and failed to open a fête. In 1974, however, he was guest of

DID YOU KNOW?

Film and television scenes have often been shot in Pinner. In 1922, the High Street and Barrowpoint were used for the hit film *Flames of Passion*. Recent successes have included BBC sitcom *May to December* (1989–94), by local man Paul Mendelson, filmed in the High Street and Woodhall Avenue; *Nowhere Boy* (2009), Sam Taylor-Wood's film about John Lennon's boyhood, with scenes in Woodhall Gate and the High Street; and *The Theory of Everything* (2014), about Stephen Hawking, which featured Pinner church.

Filming *May to December* in High Street, 1991.

honour at West Lodge Schools' fête, on condition he did not have to give a speech; instead people were invited to guess his weight.

Denis Spooner (1932–86), of Royston Park Avenue, was one of television's most prolific writers from the 1960s onwards, his credits including episodes of *Coronation Street*, *The Avengers*, and *Doctor Who*.

Pinner has been home to many actors. Timothy West, (b. 1934), star of theatre, film and television, lived here in his childhood. David Suchet (b. 1946), known for work in film and television and above all as Agatha Christie's Poirot, has been a long-term resident. Dev Patel (b. 1990), who first found fame in *Slumdog Millionaire*, comes from Rayners Lane.

Barry Cryer (b. 1935), who has lived in Hatch End since 1967, is another of Pinner's comedians, famous for both performance and writing. Also well known for work in television and radio was presenter Bob Holness (1928–2012).

2. Becoming a Suburb

Railways made Pinner a suburb. No one saw this coming when the London to Birmingham railway cut through empty fields in the north of Pinner in the 1830s, or even when Pinner station (now Hatch End) opened in 1842. By the 1850s, however, there were hints of Pinner's destiny. Solicitor Arthur William Tooke, who moved into Pinner Hill House in the 1840s, explained in 1854 that he resided at Pinner but was in London during the day. Was he Pinner's first rail commuter? Meanwhile, Pinner's first estate, the Woodridings estate, was being built, south of the Uxbridge Road near the station, a long walk from anything except the railway. Eventually there were fifty houses – semi-detached villas, with between five and seven bed-rooms, aimed at middle-class commuters (two survive in Woodridings Avenue). The first occupiers got free first-class season tickets to Euston for thirteen years. Famously they included Mrs Beeton and her publisher husband, typical in being able to afford two servants but no carriage, something which left stay-at-home wives very isolated. Otherwise early commuters were characteristically 'carriage-folk', living in grander houses, which increasingly dotted the countryside. In poorer families some young men, who must have had to walk to the station, got London jobs, for example at Euston.

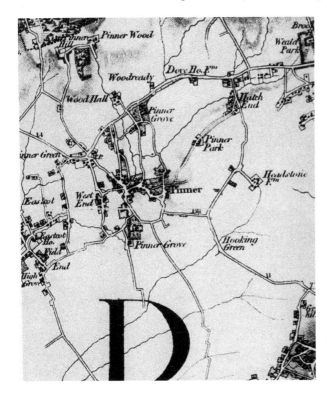

This 1822 Ordnance Survey map (detail) shows Pinner's empty countryside.

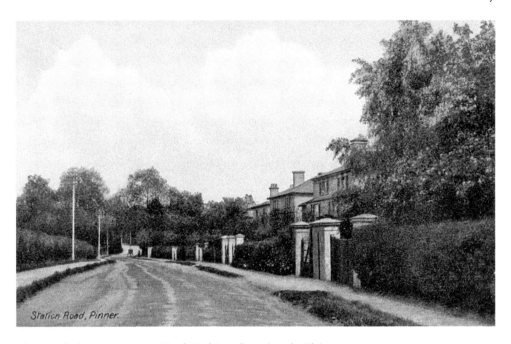

The Woodridings estate, now Hatch End Broadway (south side).

Housing for other commuters only took off after Metropolitan Railway stations opened at Harrow-on-the-Hill (1880) and Pinner (1885). Development started early at Headstone, within walking distance of stations at Harrow-and-Wealdstone and at Harrow-on-the-Hill.

A station in the heart of the village made Pinner attractive both to the wealthy – more mansions were created after 1885 – and to less wealthy people. Roads like Paines Lane, Moss Lane, and Love Lane began filling up with rather smaller houses. People moving in included civil servants, barristers and businessmen, many of whom worked in the City in small partnerships that dominated trade then. There were also some arty people. Gradually, more wholesale development, with smaller houses, followed. Stanley Villas, the Arts and Crafts-style semis in Marsh Road between Pinner station and the Library, were among the earliest developments of this type.

Some housing in this early period offered a template for later suburban estates. Particularly interesting are the black-and-white houses that foreshadowed suburban mock-Tudor. At both Waxwell Farm and Moss Lane Cottage, late Victorian owners acquired good, old timber-framed houses and enlarged them. At Waxwell Farm, the original building was stripped back and long-hidden timbers were exposed and painted black, and at Moss Lane Cottage the modern extension was itself designed as a black-and-white building. In 1897, Pinner got its first mock-Tudor shops, when the north-east corner of High Street/Bridge Street junction was redeveloped; Bridge Street's Parade followed in the years after 1908. No. 11 High Street (Friends) was stripped of weather-boarding after the owner of Moss Lane Cottage acquired the freehold in 1909 and renovated it to highlight its timber frame. At Tudor Cottage in Moss Lane, an old building, a completely new wing was created after 1909 using historic material from elsewhere. The appearance

Moss Lane Cottage. The nearest part dates from *c.* 1890.

Tudor Cottage, Moss Lane, which was remodelled in the early twentieth century.

Moss Lane's 'perky red villas'. The nearest was William Heath Robinson's.

of grand houses in the countryside and of housing developments in distant fields at
Hatch End and Headstone seems to have drawn little protest. As development around the
village centre intensified, however, people began to grieve for lost trees, hedgerows and
open land. The vicar was unhappy in 1899 when 'perky little red villas' appeared in Moss
Lane. In 1907, the local newspaper's columnist wrote of 'beautiful oaks' on the road to
Harrow 'ruthlessly hewn down' to make way for villas.

If many residents dreaded the prospect of Pinner developing as places like Kilburn had, others
were counting on it. In 1901, when Pinner Gas Co. wanted to erect another gasholder the owners
of two grand houses nearby objected because this would damage the development value of their
land. Garrard, the owner of Pinner Place, explained that he had bought a field (later Meadow
Road) near the works to build on in due course. Meanwhile the owners of land formerly part
of the Barrowpoint estate were advertising over 30 acres as suitable for building gentlemen's
residences were much grander houses than the detached and semi-detached houses. In 1906,
A. W. Marshall, owner of The Towers, bought Pinner Place and began building on its land.

Between around 1900 and the start of the First World War, it seemed there was building
everywhere. Near the village centre developments tended to be small scale, with a
preference for the Arts and Craft-style. They included houses in Cecil Park, Eastcote Road,
Cannon Lane, Meadow Road and West End Avenue. In Headstone and North Harrow,
grids of new roads were being mapped out and filled with houses. Southfield Park was
laid out, with houses appearing piecemeal. In Hatch End, there was building, for example
in Woodridings Avenue and in Royston Park, where houses were larger. One driver of
development was the opening of new stations – Rayners Lane Halt (1906), Headstone

Lane (1913) and North Harrow (1915). Planned openings were sized up by developers, who could be misled: in 1913 there was speculation in land near Pinner Green, in the belief the Metropolitan Railway planned a station nearby.

These years also saw the first attempts to preserve something of Pinner's original character. In 1905, the vicar was trying to save Barrowpoint Fields (between Love Lane and Paines Lane) as the park they resembled, with established trees, well-made footpaths and a picturesque footbridge over the brook. The parish council voted to acquire the land, but dissenting councillors demanded a poll of voters (broadly, the ratepayers) and the scheme was rejected. The vicar was more successful when it came to No. 11 High Street. When it was threatened he urged its case, partly because it was picturesque but more because it was home to the parish clerk, aged over eighty, who had been born there. The vicar's friend, solicitor Birkett, of Moss Lane Cottage, bought the freehold. (It was Birkett who renovated it after the parish clerk died.) In 1911, a local journalist, reporting that Headstone Manor Farm had been sold for development, hoped the house could be saved.

Nationally these years saw the beginnings of town planning. In 1909, local authorities were given limited powers to regulate development, if they made town planning schemes. Nearby Ruislip and Northwood Urban District Council was producing the first plan in the country. Pinner people did not want to regulate development, however. They wanted it not to happen – unless they would gain from it. The local council (Hendon Rural District Council) only began preparing a plan in 1913, spurred on by neighbouring authorities proposing plans affecting Pinner. One road planned at this date was Station Road, North Harrow.

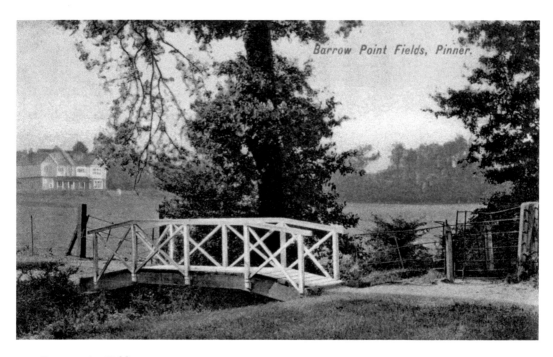

Barrowpoint Fields, c. 1905.

Inevitably the First World War caused a hiatus. Afterwards similar pressures re-emerged, with the difference that the government was eager to see 'homes for heroes' built, while the scale of development convinced people planning was necessary. In 1919, the RDC was planning Pinner's first council housing at Hooking Green (North Harrow) and in Pinner Hill Road. Private houses were soon being built along the Pinner Road, between Southfield Park and Station Road. In the 1920s the council prepared a scheme, designating particular areas for housing, shopping, industrial activity and open space. In the meantime they had limited powers to control development, but there was a presumption in favour of development and landowners had to be compensated for financial losses.

Then the fate of Headstone Manor had to be decided. For years it had been intended that any plan would provide for land around the historic farm to become a recreation ground but no plan had been finalised. The council had to secure special powers for this transaction and in 1925 agreed to buy the farm and over 63 acres as an open space/recreation ground, taking on loans largely repayable by Pinner ratepayers. The decision seems to have been comparatively uncontroversial – mistaken associations with Thomas à Becket may have helped. Headstone residents were enthusiastic, although some, particularly Pinner tradesmen, objected to such expenditure on a recreation ground far from the village centre.

It is impossible to do justice to the scale of building operations, which in twenty years between the world wars saw around 300 new roads of houses carpet Pinner's fields. Some operations were extensive enough that special sidings and miniature railways were

Headstone Manor, saved when bought by Hendon RDC in 1925.

T. E. Nash's works on the Tithe Farm estate.

created to deliver materials on site. The housing ranged from the grand on Pinner Hill to the not-so-grand, including flats above shops. Apart from the council housing, almost all was designed for the middle classes, often semi-detached houses in a vernacular revival style featuring gables, bay windows, pebble-dash, half-timbering and so on. Demand was very real, but so was competition, so builders tried to make their estates attractive to buyers: roads with trees and areas of grass echoed the garden-village look. These new estates needed new facilities, so shopping centres were planned near the stations, as well as schools, recreation grounds and churches. These new communities would soon be tested by the hardships of the Second World War.

DID YOU KNOW?

Pinner Road crosses a tributary of the Yeading Brook at North Harrow. A Pinner resident in the 1970s remembered collecting moorhens' eggs by the bridge there in boyhood, for his straitened family to eat. The brook tended to flood. Magistrates surveying bridges in 1820 could not measure the stream there because it was flooded. The problem persisted after the stream was culverted in the 1930s. Local residents remember watching films in the North Harrow cinema, with several rows of seats underwater.

In parallel with so much development went renewed efforts to preserve something of old Pinner. More widely, support was growing for retaining a 'green girdle' of agricultural land around London – open spaces were seen as an asset to Middlesex. E. B. Montesole, of East End House, who was later respected for pioneering work creating London's Green Belt, headed the local council (Hendon RDC) around 1930. Under his leadership the council sought to preserve open spaces, though landowners had still to be compensated. In 1930, the owners of Pinner Park Farm, a proposed open space, applied to develop it. The only alternative was for the council to acquire it as a going concern. The cost was shared between the county and rural district councils, with Montesole arguing that development of peripheral land would cover the cost of borrowing. This was a high point, but there were low points too. With no practical mechanism for preserving individual buildings, even something as special as Dears Farm – a fine sixteenth/seventeenth-century building in Bridge Street where Lidl is now – could not be saved, despite representations by the newly formed Pinner Association, the London and Middlesex Archaeological Society and the Society for the Protection of Ancient Buildings.

The Second World War caused people to treasure their vulnerable heritage. New ways of preserving buildings (by listing) and areas (by identifying conservation areas) were introduced and gratefully adopted in Pinner. They are crucial: in 1966, just before the High Street became Pinner's first conservation area in 1968, there was a serious plan to demolish much of the north side of the High Street and replace this with a complex of buildings including multistorey flats. They have not been enough to prevent tragic losses, for example of the older portion of West House, demolished by the cash-strapped council, which held it in trust, and the Railway Hotel, the oldest surviving building in Hatch End Broadway, lost to Tesco. The last is an example of the inadequacy of local listing, which cannot fully protect properties that may lack national importance, but contribute to the individuality and sense of history of their area.

The biggest change in Pinner since the Second World War has been the arrival of thousands of ethnic minority families. The lived experience of the newcomers and the many ways in which their presence has enriched local culture and changed local high streets are becoming history and urgently need to be documented.

Dear's Farm, Bridge Street, demolished in 1935.

Old Houses—Pinner Village.

3. Crime, Punishment and Policing

A Lawless Pinner?

Pinner was never known for lurid crimes but has seen a surprising range of offences, and ways of policing them. It was perhaps most lawless between 150 and 300 years ago. The theft of animals – sheep, horses, pigs, cattle – was a particular problem. Sometimes servants stole from their employer's homes. There were highway robberies – riders stopping travellers at pistol-point – with Pinner connections: three cases on local commons around 1790 involved Pinner victims or arrests. In 1793, a gang led by a man from Paddington stole the lead from Pinner church roof overnight.

Pinner Common, around Pinner Hill Road, with its handful of cottages, was apparently Pinner's badlands. Thomas Reading was acquitted in 1836 of stealing a lamb found dismembered in his cottage there. He claimed he found it, dead, beside the road. The Armstrong brothers, railway workers, also lived there and several were accused of theft. William Armstrong was transported for seventeen years in 1838 for stealing a ewe.

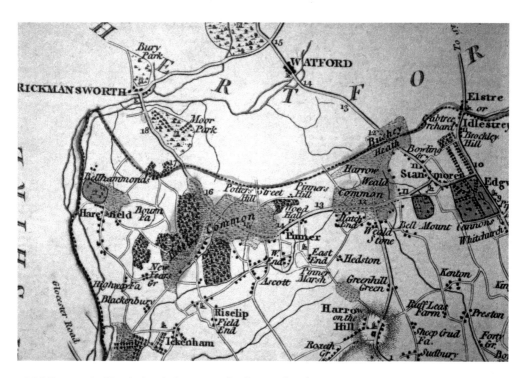

Middlesex, 1787 (Cary): detail, showing Uxbridge Road and commons.

A recurring problem was Headstone Races, held in a field north of today's Southfield Park. In 1834, 1839 and 1899 men were arrested for pickpocketing there. The year 1899 also saw rioting, perhaps after a disputed result, overwhelming the few policemen present. The races were never held again.

Penalties were intended as deterrents, because criminals were rarely caught: these cases often led to hangings. Why did malefactors take such risks? Some crimes seem born of desperation. In 1799, Daniel Munday, perhaps a deserter, stole a lamb and butchered it in nearby Pinner Woods. The farmer found him with the meat in his cooking pot. He was sentenced to death. Others seem the actions of overconfident young men. In 1820, Pinner butcher Thomas Bransgrove (twenty-three) stole ten cattle from Hayes. He brought them back to Pinner where locals helped drive them to his slaughterhouse. He sold a fore-quarter to the workhouse, and sent meat by cart to London and skins to Watford. He too was sentenced to hang. Juries or prosecutors sometimes recommended mercy. Transportation became a common sentence. In 1826, two lads ran behind Turner's Pinner stagecoach and stole a bag from the boot. They were sentenced to seven years' transportation. Later, prison sentences became normal. Sympathetic juries might acquit someone regardless of evidence – for example John Hitchcock, who had admitted taking a penknife, bacon, a pudding and gin from a Pinner house. It had been suggested he was half-witted, and he had been in prison a month.

How were people caught? In domestic theft cases prosecuted, the victim usually identified the thief. With animal thefts, crimes might be spotted by outsiders, like Watford tradesmen who recognised brands on skins they bought and travelled to Pinner to test their suspicions. Criminals were pursued remarkable distances. In 1731, two highwaymen were followed from Hayes to Pinner, where they rested in a field. One was captured by the field's owner, out with his gun. Two men who robbed someone on Stanmore Common in 1789 were followed to an unnamed Pinner pub. In 1791, a Pinner Park Farm employee John Baldwin bought a horse stolen from Southall; he and the horse's owner tracked the thief, who was found between Stanmore and Elstree.

The Start of Professional Policing

Before police forces everyone had a duty to pursue criminals. Parishes had constables, often involved after someone had been captured. The role of parish constable was rotated among local householders, who continued their usual occupations. In cities, people might pay a deputy, leading to the development of semi-professional constables. We do not know if this happened here: we have only the name of the occasional early constable – 'Simon' in 1794, for example. Parish constables were sometimes appointed after a professional force existed. In Pinner in 1860 shoemaker James Gladman said he was Pinner's parish constable.

From 1805, Bow Street patrols covered roads into London. Albert Pell, of Pinner Hill House, remembered the comfort these afforded on roads 'infested' with 'cattle-stealers and footpads'. After 1829 they were replaced by the Metropolitan Police. Initially they policed an area around 10 miles from London, which was extended in 1839 to 15 miles (including Pinner). Fragments of evidence about Pinner do not quite fit this template.

One Pinner family believed their ancestor, Thomas Ashby, had been Pinner's first constable. In 1930 they had his truncheon to confirm the account. (This badge of the constable's office was sometimes displayed outside his home.) Ashby was also licensee of

The Bell, Pinner Green, which was Thomas Ashby's pub.

The Railway Hotel, where Sergeant Goddard was stabbed.

the Bell in the early 1820s. In 1826, a man arrested in Pinner for stealing an overcoat and held overnight in Pinner's cage, was escorted to London by Ivory Dean, another Pinner constable, in connection with an earlier theft.

In 1836, Joseph Higgs described himself at the Old Bailey as 'constable of Pinner': he appeared in Pinner cases until 1843, then identified as sergeant S30 (a Metropolitan Police collar-number). He apparently lived at Pinner Green. He probably first appeared in Old Bailey cases as a Bow Street horse patrol, a carpenter by trade, based in Hanwell, from 1826. He was a responsible and thorough officer. In 1843, for example he stopped a carter with a load of corn and chaff stolen from Tilbury's stud in Hatch End, at 3.30 a.m. In court, Higgs explained they followed the cart's tracks back to Hatch End (it had rained recently and no other cart had passed since) and detailed evidence was produced that the stuff in the cart matched that at Tilbury's. It is puzzling that Pinner should apparently have had a Metropolitan police constable in 1836, and that Higgs appeared in the 1841 census as a greengrocer.

In 1841, no policeman was identified in Pinner (apart from a railway policeman). In later censuses one can see the Pinner force growing: in 1851 there were three constables, four in 1871 and in 1881 four constables and a sergeant. In 1857, the unfortunate Sergeant Goddard was stabbed by a drunk he had been asked to eject from the Railway Hotel (near Hatch End Station).

Crime and Policing before 1700

Earlier, the lord of the manor had jurisdiction over minor crimes. Manorial documents record cases when Pinner people assaulted their neighbours and so on. Policing was by parish constables and officials like ale tasters who enforced particular regulations, all chosen from villagers at the manor court. On one occasion those assaulted were the ale tasters.

Major crimes went before royal courts, so we may know a Pinner person was hanged (because his forfeited property concerned the manor court) but not why. In one exception, in 1468, John Morgan, who owned a High Street cottage, robbed John Edrop. He was arrested by Roger Estend, escaped, was re-arrested and, while in the custody of Constable Henry Estend, was induced to transfer his cottage to Edrop. If this was meant to resolve matters, it failed. Morgan was hanged, the transfer declared void (though five years later Edrop was granted the cottage), and Roger was fined. In 1595 and 1622 Pinner men stole sheep. Three out of the four escaped hanging by a historical anomaly – 'benefit of clergy'. In the Middle Ages, clergymen were judged by church courts, which did not impose the death penalty. You proved you were a clergyman by reading a Bible verse in Latin, supposedly something only a clergyman could do. In practice there were educated laymen by then, though it is startling that two who passed the test were described as 'labourers'. In an eye-catching case in 1585, a Harrow Weald woman was accused of causing the death of Rose Edlin of Hatch End by witchcraft. The outcome is unknown.

Pinner Police Station and Beyond

From the late 1700s, Pinner had a lock-up, or cage, roughly where the embankment is behind Bridge Street Gardens. This was a short-term holding place for drunks and others who had been arrested. In 1827, it was moved to the nearby workhouse site, but was out of use by 1893, when it was explained Pinner had arrested no drunk for ten years, having nowhere to put them.

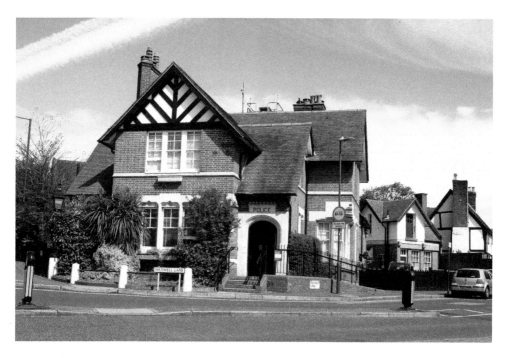

Pinner police station, opened 1899.

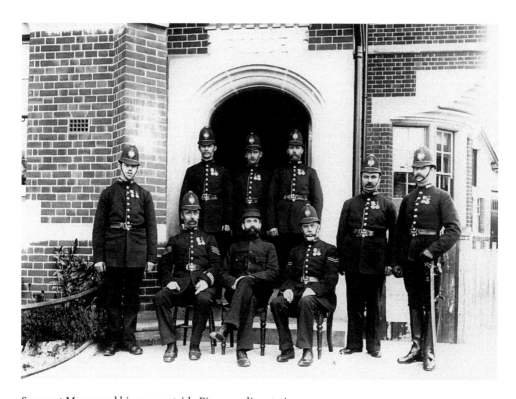

Sergeant Moore and his men outside Pinner police station, *c.* 1900.

The police station in Bridge Street opened in 1899 and for the next forty years or so Pinner was probably more intensively policed than ever before or since. The first floor housed the station sergeant and his family, police business was carried out on the ground floor, while the cellar contained three cells. The stable was used by a mounted constable; local children long remembered PC Killingback's white horse. Edwardian Station-Sergeant Fishlock grew roses in the garden – in 1939 there were fruit trees and bee-hives. In 1907, Pinner's force comprised two sergeants and fifteen constables.

Policing involved constables walking beats from Pinner to Hatch End, for example, in eight-hour shifts, day and night. Most offenders were local drunks; people who cycled on pavements or had no lights on bicycles or carts; or householders whose dogs did not have details on their collars. Occasionally, police mounted a speed trap in Uxbridge Road, where a good stretch of road encouraged early motorists to exceed the national speed limit – 20 mph. One crime-prevention measure was for police to meet the last train into remote, unmanned Rayners Lane, in case it carried evil-doers.

The monotony of this appalled PC Greaves. A London policeman, he had featured on the front page of national newspapers when he contradicted his sergeant's evidence in the sensational trial of Steinie Morrison. He had been assured giving honest evidence would not damage his career, but saw his posting to Pinner in 1911 as a punishment. His grievances became part of the campaign for a police union. He said Pinner contained little but mud and trees. There was no provision for meals during his eight-hour beat. Nothing happened; in the four months he was in Pinner the only policing he did related to a dog and was not pursued. This might suit a 'clodhopper' but there was no prospect of advancing his career.

There were minor excitements. Pinner fair was one challenge. There were thefts: for example, an ex-servant stole a watch and other items from servants at The Hall, and was immediately suspected, having been spotted in the area. A Harrow detective (Harrow headed Pinner's subdivision) found the property in a London pawnshop. In 1912, two men from London's East End worked their way round Pinner shops buying

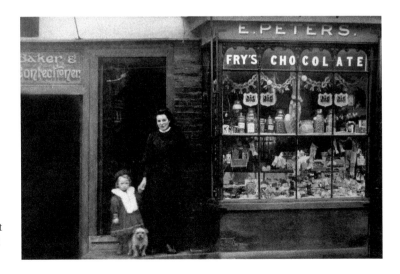

Probably Elizabeth Peters, a High Street shopkeeper cheated in 1912.

tiny things – chocolate, for example – for a penny, with two-shilling coins. Shopkeepers testing them afterwards found them forged. Soon there was a gaggle in High Street comparing notes and the police were alerted. In 1905, a servant who had concealed her pregnancy hid her dead baby in the laundry, and in 1911 a depressed mother gassed herself and her toddler but herself recovered.

Those arrested might be held overnight at the station. A neighbour, Mrs Paradine, provided meals. If someone had to remain longer pending trial, an 'occasional court' would be arranged at the station before local magistrates including Hogg of West House.

GROVE ROAD, PINNER.

Marsh Road houses, c. 1906. The second was medium Craddock's.

DID YOU KNOW?

In a sensational case in 1906, Lt Col Mark Mayhew, backed by the *Daily Express*, sought to expose as fraudulent the medium Frederick Foster Craddock, who briefly operated at a Marsh Road house (now Pinner Bridge Club). During séances, participants held hands in a circle, in darkness, while Craddock was 'possessed by spirits'. The case was heard in a courtroom 'packed to suffocation', with 'snapshotters hid ... behind bulky people', before an extraordinary twelve magistrates including W. S. Gilbert. Craddock was fined £10, but convinced many before and after.

S 4900 **STATION ROAD. HATCH END. PINNER.**

WHSmith's, Hatch End, the scene of Sergeant Fishlock's downfall.

A memorable case involved the tragic end of Sergeant Fishlock himself. In 1918, when he might have retired after twenty-five years' service, eleven as Pinner's sergeant, had he not continued voluntarily because of the war, he began stealing from WHSmith's kiosk in Hatch End. The manager evidently alerted Harrow, as senior officers from Harrow staked out the store and saw Fishlock come out with a purloined adventure story. Some 250 shoplifted books were found in his quarters. At this point he was diagnosed with a mental breakdown and sent to an asylum, where he hanged himself.

Recently Pinner has remained little troubled by serious crime. Before most pubs closed these could be a focus of drunken brawling and occasional stabbings. A common problem has been burglary, with criminals from elsewhere drawn by Pinner's comparative prosperity. Occasionally this has involved violence, including cases when Asian families have been intimidated by armed men invading their homes in search of gold. In the most serious case in 2000 a householder in the Uxbridge Road who pursued a burglar was stabbed to death, with a screwdriver, by a career criminal with a temporary camp on Pinnerwood Farm. After various reorganisations, volunteers began a help desk at Pinner police station in 2002.

4. Roads and Railways

Early Roads and Bridges

Everyone who travels round Pinner uses roads dating from the Middle Ages, though layers of tarmac separate us from a thousand years of history. In general, roads called 'Street' or 'Lane', and many called 'Road', are the old ones.

From the Middle Ages, a network of roads and paths linked the village centre to its hamlets, the hamlets to each other and villagers generally to the wider world – most importantly to key markets. Roads were generously laid out, particularly at junctions, providing ample space to turn unwieldy early wagons. Junctions often took the form preserved at Tooke's Green, a triangular central green surrounded by tracks followed by road users according to the direction they were going in. There were greens like this, for example, at Pinner Green; where Chapel Lane emerges onto West End Lane; and at the top of Bridge Street. At the top of the High Street, in 1391, Richard Downer was given permission to build on land now occupied by the timbered building seen in front of the church in most photographs – then an island site.

Tooke's Green, sole survivor of Pinner's medieval greens.

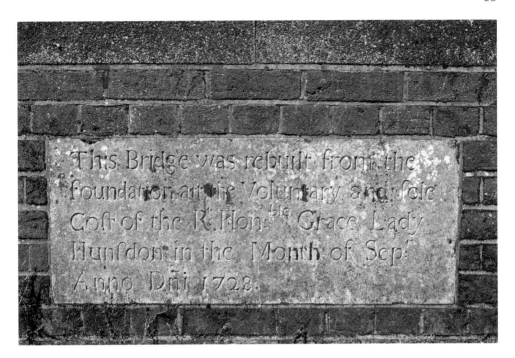

Plaque, Cannon Lane, recording construction of an earlier bridge.

Roadways were also usually wide where they crossed our many streams, originally at fords. By the 1600s stream crossings often had footbridges beside fords. In Bridge Street there was apparently a bridge that could take vehicles, but if so it did not last, and in 1800 there was only a ford and footbridge. All these bridges were wooden and there were recurring disputes about who should maintain them. In 1728, a good bridge was erected in Cannon Lane – then a route to the open fields – by Lady Hunsdon, whose family was responsible for maintaining the bridge there. Elsewhere, for example in Paines Lane, streams were culverted to make bridging them simpler. In 1820, the Uxbridge Road, long Pinner's best route to London, still crossed three fords before you even reached the turn for Watford.

Maintaining roads was the responsibility of local people, but Pinner was neither rich nor populous, and our clay soil is horrid. Understandably, roads were poor. As late as 1898 Pinner's roads were described as 'impassable for mud for five months out of twelve'. Local people coped, of course. People and animals on foot and horse-drawn vehicles can get over bad ground, slowly, if they are not too heavily laden – or go the long way round. We have plenty of evidence of Pinner people trading in London and market towns including Harrow, Watford, Rickmansworth, Uxbridge and Brentford.

Toll Roads

By the 1700s there was pressure nationally for better roads for long-distance travellers, especially to London. This resulted in turnpiking, privatising stretches of main road. Parliament would authorise local worthies to take over a length that needed improving

as trustees: they would borrow for improvements, recovering their costs from tolls. Work included upgrading road surfaces, usually by adding quantities of gravel. Pinner was not on any key route, so was not directly affected at first.

The first turnpike important for our area was on the Edgware Road. The stretch from Bushey to Kilburn was turnpiked in 1711. This was the route into London favoured by local people, used, for example, by early Pinner stagecoaches, and by local men like Andrew Knox of Barrowpoint, who had business in London. The route from Harrow to London (via the 'Stone Bridge' over the Brent at today's Stonebridge) was turnpiked in 1801.

Pinner finally joined the network when a turnpike from Harrow to Rickmansworth was authorised in 1809. The turnpike trustees included Richard Aubery of Pinner Place, Daniel Hill of Church Farm and Francis Milman of The Grove. They met at the Queen's Head. Improvements they authorised included a brick bridge with two arches over the Pinn in Bridge Street. The toll road came into Pinner along the Rickmansworth Road (having passed a toll gate in Northwood where The Gate pub is now). It went past Pinner Green (where there was another toll gate), down today's Elm Park Road into Bridge Street, up the High Street and out by the church along Church Lane (then the main road to Harrow) and through Nower Hill to today's Pinner Road. Then it followed our usual route

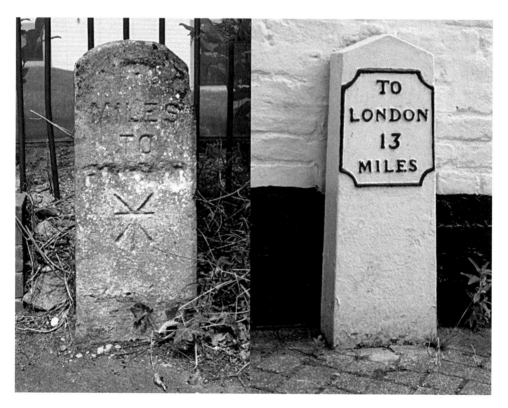

Milestones at Pinner Green (eighteenth century, probably damaged *c.* 1940) and Bridge Street (*c.* 1810).

Pinner Bridge, *c.* 1830: Bridge Street (left), Marsh Road (right), and High Street with today's Victory (centre).

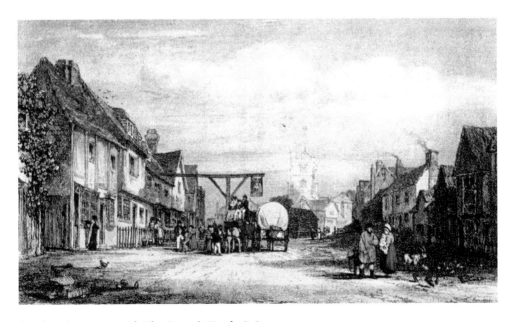

Coach and wagon outside The Queen's Head, 1828.

to Harrow, passing another toll gate roughly where the road crosses the Metropolitan line, before going over Harrow Hill and out towards Sudbury. Tolls were paid for animals passing the gate: 4d for each horse pulling a carriage, 5d for twenty sheep and so on. Pedestrians were not charged.

Gatekeepers at Pinner Green are named in censuses: widow Ann Dewsell, who lived with her daughter, in 1841, and in 1851 Emma Dyer, a single woman of thirty living with her sister. James Bedford (b. 1826) had a story about a man on a hunter who wanted to go through the gate without paying, to drink at the nearby Bell Inn. When gatekeeper Jimmy Dyer (Emma's father?) refused to let him, he jumped the gate, had his drink and went home via Pinner Hill to avoid the toll again, coming back the other side to tell Dyer what he thought of him.

Another big change affected Pinner's roads at about this time. When Pinner's common land was enclosed around 1815, this included enclosing the generous verges and greens. Better road surfaces, vehicles and bridges made it possible to make roads narrower. The land freed up was often allocated as part of their share of the common lands to owners of land next the road, enlarging fields or estates. At the spacious junction of Paines Lane and Uxbridge Road, for example, land including a pond became part of The Hall's estate. Elsewhere those with small entitlements were allocated little plots beside roads, where cottages were often built later. One road significantly narrowed was Bridge Street, which then had to be widened again in the 1930s.

DID YOU KNOW?

In 1791, Andrew Knox, of Barrowpoint, who had a tailoring business in London, was robbed by highwaymen while crossing Harrow Weald Common on his way home. He would have been using the turnpike road, now Edgware Road, and then the Uxbridge Road. It was a September evening between six and seven and raining heavily. The thieves were young men, eighteen and twenty-one. They were sentenced to death, with Knox recommending mercy. He explained his reluctance to identify one robber, knowing he would face hanging.

Stagecoaches and Carriers

Few people could afford their own carriage, so Pinner was fortunate to have a stagecoach service to London from the 1780s to the 1840s, usually run by the Turners, who kept the Crown Inn at the bottom of the High Street and later the Queen's Head. Before the Pinner turnpike, it went via Stanmore; thereafter it passed through Harrow. John Graham of Nower Hill (born around 1828) described journeys on the coach in its later days. It was drawn by two, three or occasionally four horses. It left Pinner between 7.30 and 8 a.m. It might carry fifteen passengers, including those picked up in Harrow: around five passengers would sit inside, in places usually kept for women and the frail. Outside

1690.—The Old Blue Boar, Holborn.

The Pinner coach's Holborn destination around the time journeys ended.

passengers would get out to climb Harrow Hill, and might help push the coach. Even so, the horses needed a rest halfway up. Horses were changed at Stonebridge. The coach stopped in Oxford Street before terminating in Holborn. The return journey began about 3.30 p.m. Winter journeys were unpleasant, especially for outside passengers: James Bedford's father was once stuck overnight in the coach in snow. Coach services ended soon after Hatch End station opened.

Those who could not afford the coach might walk to London, or go to Northolt and travel to Paddington by barge. Goods might be sent by the coach, but there were also carriers, a service that began before the coach and continued into the twentieth century. Pinner's stagecoach was not a mail coach, because before there were railways, our post came from Watford.

The Coming of the Railways

The London–Birmingham Railway (opened in 1837), which cut through the north-east of Pinner, was one of London's earliest railways. At first the main impact here was on farms whose land it crossed. The main access route to Pinner Park Farm, from Headstone Lane, was cut, and there was a level crossing here. At Hatch End Farm (now Letchford House, Headstone Lane), effects were even more drastic. The railway divided its land in two, and occupied much of it. The owner, Benjamin Weall, compelled the railway company to buy the entire farm. The farmhouse became a base for the contractor constructing a large

stretch of the line. Wooden cottages in Pinner Hill Road ('the Rabbit Hutches'), originally on Pinner Common, were believed to have been built for men constructing the railway; these survived until the 1920s. James Bedford recalled that when the railway opened, his father warned him not to go near it for fear of being 'blown up'. He also remembered early 'Puffing Billy' locomotives.

Hatch End station (then called 'Pinner') opened in around 1842. Originally, as Bedford said, there was only 'a little bit of a shed, just enough to hold two or three people', with people at first afraid to travel. Within a few decades Pinner's residents included railway workers, both men working locally, like the station master and signalmen, and clerical staff based at the London and North-Western Railway (LNWR)'s headquarters at Euston. Many were newcomers but some were local people, including two sons of the Pinner Hill House butler, who became railway clerks. By 1900 Pinner housed LNWR bosses, notably Frank Ree, later their general manager, and John Parkhouse, their accountant. The latter was said to have facilitated the paths of Pinner lads to LNWR clerkships, so the village schoolmaster said this was the ambition of most local boys. The railway also brought Pinner's first commuters, some on a new estate at Woodridings (now Hatch End Broadway), and the Commercial Travellers Schools, on part of the Hatch End Farm land sold to the railway company. The school for orphaned children of commercial travellers occupied imposing Gothic buildings where Harrow Arts Centre and a Morrisons' supermarket are now.

By the 1870s it was evident that the Metropolitan Railway would open a station at Pinner. Railway contractor Francis Rummens is said to have bought Cannons Farm as a speculation, believing the station would be on its land near Cannon Lane. The route

Hatch End station, c. 1905, rebuilt in 1911 when local lines were constructed.

The Commercial Travellers Schools (opened 1855) faced the railway.

actually chosen involved the loss of Marsh Farm (buried under Station Approach) and of the Baptist chapel, which with the Methodist chapel had given Chapel Lane its name. Some cottages nearby also went. After Pinner station opened in 1885, the former occupier of one, Catherine Langthorn, wrote to her Australian émigré son: 'Pinner is quite spoilt since the railway came'. The LNWR, fearing they would lose traffic, started a horse bus service between Pinner and Hatch End station. The population began to multiply.

A Commuter Suburb

Soon many Pinner households included at least one man who commuted, usually to the City, along with some women. The railways played a bigger part in their lives than in ours, because there were few other ways to get about. Over the following decades, the service from Pinner was improved by constant upgrading: doubling of lines, electrification (initially south of Harrow), improvements to rolling stock and rebuilding at Baker Street permitting direct trains to the City. The construction of the Uxbridge branch and intermediate stations – Rayners Lane (1906), Headstone Lane (1913), North Harrow (1915) – opened up new areas for housing development. From 1917 until 1982, Hatch End station was served by the Bakerloo line.

Motor vehicles also brought big changes. From around 1905 roads were tarred, starting with the High Street, to tackle the damage that motor vehicle tyres did to traditional road surfaces. The first motorbus service, replacing the horse bus, began in 1914. Car ownership became common: by the 1930s even modest houses might be built with garages, though roads and front gardens were not filled with cars as they are now. A motor showroom was a dominant feature in the new shopping centre at North Harrow,

The Metropolitan Railway's coat of arms on a restored carriage.

and garages selling petrol and offering repairs opened all over our area. One was Watsons' Garage (now the Tyre and Exhaust Centre) in Bridge Street, with petrol pumps that swung out over the street. New main roads were planned and sometimes built. Some, like Alexandra Avenue, gave access to new areas of development, while others were intended to facilitate car journeys. Today's residents have reason to be glad some never materialised. A 'Pinner bypass' mooted in the 1920s would have taken traffic from Whittington Way and Lyncroft Avenue via Northfield Avenue to the Rickmansworth Road. George V Avenue was planned in the 1930s to run through Nugents Park (a proposal successfully opposed by affluent house owners there) and to carry a main road via Altham Drive to Watford.

DID YOU KNOW?

Pinner has had two short-lived flirtations with aviation. In 1912, the Rummens' brothers tried to open an airfield near Cannon Lane and in the 1930s Arthur Ord-Hume built an aeroplane that he flew from a field near his home in Evelyn Drive.

5. Farming and Industry

A Thousand Years of Farming

Until around 150 years ago Pinner was an agricultural community. It had few natural resources and was not on a major route or waterway, so never became an industrial or trading centre. Edward III's grant of the right to hold a weekly market (1336) was not enough to turn it into a market town. So, for hundreds of years, almost everyone who made a living in Pinner either farmed or provided services to those living locally. Almost everyone who lives in Pinner now lives on land that was farmed for hundreds of years. Over that time, some things changed mightily, while others were amazingly lasting.

Take the farms themselves. Pinner Park Farm is the most obvious example of continuity. Formed as the archbishop's deer park by 1273, it was converted into a farm in the 1500s. This involved clearing trees, which was not previously necessary. By 1547 land south-east of the footpath that cuts across the farm was being ploughed for crops, while the other side was grassland for cattle, described as unsuitable for ploughing, because no one had removed the tree roots. In 1746, the farm's main income came from dairy cows, whose milk was made into butter, sold in all the nearby markets (London, Uxbridge, Harrow, Watford, Brentford). The farm also produced hay, wheat and beans, and sold its surpluses, as well as pigs fattened on buttermilk, unwanted calves and firewood. The disintegrating eighteenth-century creamery, a listed building, is a legacy from this era. By 1900 the farm was almost entirely grassland, producing hay and animals for meat. Dairying returned in the 1920s, with Halls' Dairy supplying milk to the local area until 1999. Today's farmers are breeding beef cattle.

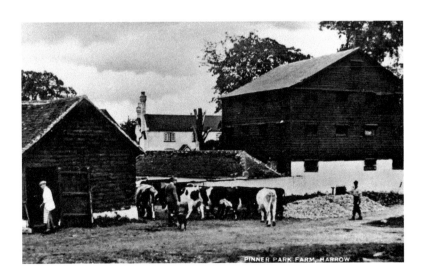

Dairying at Pinner Park Farm, 1930s.

Pinner Park Farm is exceptional – the last agricultural land in Pinner. Elsewhere farming generally ended in the 1930s, making way for housing. Much of this land had actually been cultivated longer than Pinner Park. At Headstone Manor and Woodhall Farm, some land had been farmed since at least the 1200s. These were among Pinner's largest farms. Nearer the heart of the village, where land was probably being farmed in 1066, smaller holdings were more likely to be reconfigured, with bits divided or added or sold off, but there was still continuity. At East End Farm, for example, Henry Hedges in 1910 was farming land owned by several different landlords, but at its core was 9 acres he rented with the farmhouse, almost certainly part of the holding of William 'Estend' in 1429. West House preserves the holding which once belonged to William Aldridge. It was farmed until around 1814, when the house became a gentleman's residence. (Even then some farming continued: the twentieth-century owners kept cows for milk, grew hay, and raised pigs on the estate.)

Changes in Farming in Pinner

The biggest change during Pinner's time as a farming community was in the early 1800s when the huge open fields, which contained most of the land that grew crops, were enclosed and divided between individual owners. This was the climax of centuries of change.

In the Middle Ages – around 1200 – most Pinner people would have lived mainly on things produced in Pinner. They would have eaten beans, bread and, if they were lucky, bacon, grown and baked and reared and smoked here and cooked over fires fed with local wood. Their clothes would have been made by Pinner people, often of wool from Pinner sheep. The better-off would have sold surplus produce, to pay rents, for example, and early records contain cases of people buying and selling in London. In this economy, each part of the village played its part. The open fields grew wheat and barley, peas and beans. In each field crops would be grown in rotation: perhaps wheat one year, beans in the next, and nothing in the third, which prevented fields being drained of nutrients or becoming a breeding ground for pests. After harvest, villagers could turn their animals out into the fields. Around their homes, they grew vegetables and kept animals. Firewood came from the woods, where pigs ate acorns in the autumn. The commons were shared grazing land.

By 1800 much had changed. Woodland had been cleared, forming new farms at Pinner Wood, Hatch End and Woodridings for example, and small areas of the common and outlying bits of the common fields had passed to private owners. Land that once belonged to Pinner's yeomen, who cultivated it themselves, had generally passed to distant landlords, who rented it to the actual farmer. In England generally, a market economy had developed. Farmers were selling crops for money, which paid the rent and enabled them to enjoy some luxuries. They supported growing urban populations, and more non-farming tradesmen and craftsmen, even somewhere like Pinner. The basic system remained, but it was under pressure from modernisers.

Various improvements made farming more productive: new ploughs, requiring fewer horses to pull them; new crops, like clover and root vegetables, eliminating bare winter fields and the need to leave land fallow; selective breeding of animals; and machines, for planting seeds and threshing, for example, more efficient than human labour. All were

comparatively easily introduced on private farms. This was the time of improving gentlemen farmers, who read and wrote treatises on best agricultural practice. One was John Claudius Loudon, who lived briefly at Woodhall Farm, which his father rented for the last two years of his life. John published details of schemes he devised for improving the farmhouse, the farmyard and cultivation there, but moved on before they could be introduced. At Pinner Park Farm, James Deacon Hume, farmer from 1806 to 1824, did make changes, enlarging the farmhouse, building new buildings including the granary now at Headstone Manor, and introducing a horse-powered threshing machine. By 1865 (and probably earlier) there were also threshing machines at Woodhall and Pinner Hill Farms. At the last, the horse circle and part of the machinery survive.

More productive farms were a boon because the population was surging. Contemporaries were concerned that Britain could no longer feed its population, a fear heightened when wars with Napoleon's Europe and with America disrupted trade. Experts urged the government that common land should be enclosed. Then, they hoped,

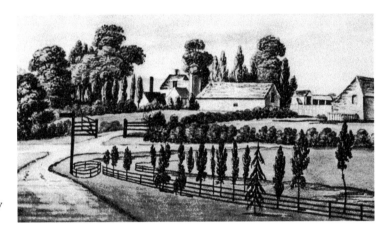

Woodhall Farm, c. 1807, from across the Uxbridge Road by Loudon.

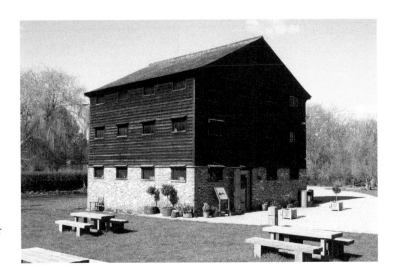

Granary from Pinner Park Farm, now at Headstone Manor.

open-field land would be more efficiently farmed and commons would be brought under cultivation. In Pinner the bigger landowners backed enclosure, expecting to gain, as enclosed land was distributed according to the size of people's holdings in the common fields. Despite some opposition, Pinner lands were enclosed around 1817. The open fields and the commons were broken up into private holdings and, after some swapping and selling, new farms emerged to work the newly enclosed land.

These included the farm eventually known as Tithe Farm, with its farmstead beyond our boundary at what is now the junction of Eastcote Lane and Alexandra Avenue. Belonging to Christ Church, Oxford, it had extensive land in both Pinner and Harrow. At enclosure the obligation to pay tithes (owed to the church) was often extinguished. The college, which had long ago been given the right to Pinner's tithes, received this land in compensation. Other farms that emerged were Temple Farm (near Eastcote Road), Downs Farm (off Cannon Lane), and Hope Cottage (later Barters Farm, near the Headstone Lane/Pinner Road junction), all working former open-field land, and Pinner Hill Farm, on the old common.

It is not clear that enclosure generated the intended boost to productivity in Pinner. The early 1800s were a time of dreadful weather and bad harvests. When Britain achieved peace with France and America, Corn Laws, introduced in 1815, taxed imported wheat to protect struggling farmers. This was unpopular with the hungry urban poor and with merchants who benefited from trade. After the Corn Laws were repealed in 1846, Britain became dependent on imported wheat and in the 1860s also on meat imported in refrigerated ships. For most of the 1800s farming was in depression. In Pinner, even before 1800, farms tended to grow more hay than wheat or other crops requiring ploughing, which on our clay soil was heavy work, increasing labour costs (a problem noted at Headstone Manor in 1840). After enclosure, wheat was grown for a while on land formerly in the open fields. John Graham (born around 1827) remembered wheat waving

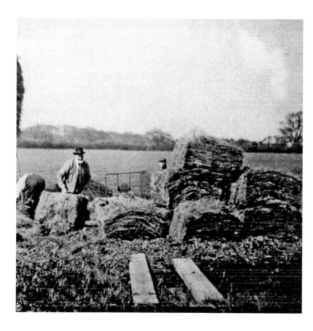

Farmer George Barter in Barter's Farm rickyard with hay bales.

Cows from Hedges' East End Farm moving between fields, *c.* 1908.

DID YOU KNOW?

Rayners Lane owes its name to a family of agricultural workers. At enclosure, Daniel Hill of Church Farm became owner of lands either side of the lane (previously used to reach the open fields). He built a cottage and farm buildings roughly where Buckingham Preparatory School is now. George Rayner, and later his son Daniel, lived there with their families from around 1830 to 1870, and worked Hill's fields. Some fields and the lane came to be known by their name. After Rayners Lane station was built, their name became attached to the new suburb.

in the breeze either side of the road to Harrow and wheat straw being sent to St Albans, a centre for making straw hats. This did not last. When Pinner's windmill burnt down in 1872, it was not worth replacing. (Its surviving buildings became the core of another tiny farm.) The last hint of wheat being grown locally is that in 1901 Moses Sibley of Woodridings Farm described himself as 'farmer and corn-reaper'. By 1907 almost all Pinner's agricultural land was grass, for grazing or haymaking. The exceptions were odd acres of orchard, root vegetables, clover etc., as there was no grain at all. This gradual change was accompanied by a decline in the number of Pinner people working in agriculture. In 1841 Pinner had nearly twenty farmers and more than 150 agricultural labourers; in 1911 the number of farmers was about the same but there were fewer than fifty men working on their farms.

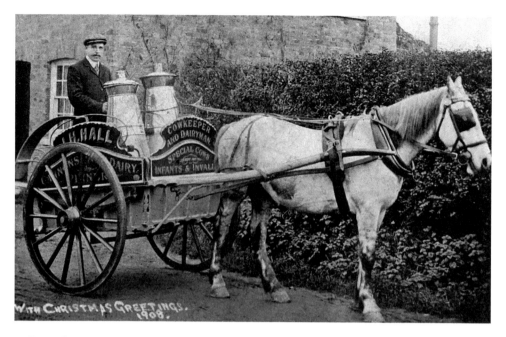

Milk cart from Cannon Farm, 1908.

During its last years as an agricultural village, Pinner – like Middlesex as a whole – was known for its hay. There was a ready market in London, where horse-drawn traffic proliferated until around the First World War. For decades great horse-drawn hay wagons set out for London each evening, while every farmyard held its hayricks. Haymaking was a big event, drawing in many itinerant workers.

Animals were also being raised here for meat, though this was probably declining. Pinner had four shepherds in 1881, for example, and only one in 1911. People who lived in Pinner before the First World War remembered sheep being dipped in the dammed stream on Woodhall Farm (the stream lies under Woodhall Gate today) and a local farmer and butcher shaking hands on their deals. The other main form of farming then was dairying. Thomas Wilshin (b. c. 1853) recalled his father being the only milkman in the village, but by 1910 there were at least ten dairy farms in Pinner, supplying the growing local population with milk from small dairy herds, and sometimes sending milk to Wealdstone or London.

Pinner's Two Industries

Pinner had one natural resource, which resulted in small-scale industrial activity: chalk. In its natural form, chalk was scattered on fields as a soil-improver ('marl') and pulverised for whitewash. Burnt, it made lime, an ingredient in mortar and limewash, essential for early builders. Chalk lay near the surface beside the northern half of Waxwell Lane, where it was quarried from at least the 1330s. Flints, found in bands within the chalk, were useful for bases for timber-frame buildings and to build Pinner church. When this area had been quarried out, chalk was mined north of the Uxbridge Road, where it is further down, usually by sinking shafts down to the chalk layers. The lord of the manor licensed

mining on common land by the Bodimeades and Blackwells, brick makers at Harrow Weald, while landowners at Pinner Hill and Woodhall Farm also sponsored mining. Chalk mined and burnt in Pinner would have been used locally. Mining ended around 1870, when railways made it cheaper to get chalk and other fertilisers from places where it cost less to extract. By far the largest mine is under The Dingles quarry, east of the Montesole Playing Fields. There is a much smaller mine under the Pinner Wood School playing field.

As this industry folded, the only other significant industry in Pinner's history was getting going: the manufacture of gas. In 1863, the Pinner Gas Company. was established with works in Eastcote Road, opposite the Cannon Lane junction, where gas was made from coal brought in by rail and cart. In 1880, it provided Pinner with its first street lighting – six lamps in the High Street. Over the following decades, demand increased for gas for street lamps and for domestic stoves and lighting. Additional gasholders were constructed in 1896 and 1902, with the works supplying gas as far away as Harefield. By 1911 around sixteen Pinner men were employed there. Few pictures show the works, which must have dominated this part of Pinner. Gas production here ended in 1931.

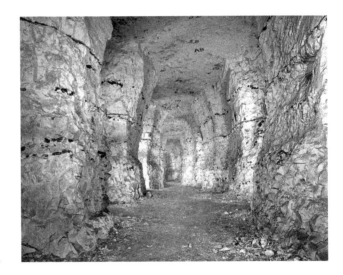

Pinner's last chalk mine was inoperation worked *c.* 1850–70.

A rare glimpse of Pinner's gasworks.

6. Shops and Places of Refreshment

The High Street: Pinner's First Shopping Centre

Pinner would once have been largely self-sufficient, but individual households were not. From the time that records let us glimpse the village community, there were specialists who supplied things not easily produced in every home. They included bakers, for example, as villagers generally would have cooked over open fires and had no oven. By the 1400s Pinner had a butcher, a baker and a candlemaker, or at least someone supplying provisions like cheese, spices and dried fruits, known variously over the centuries as a victualler, chandler (or candlemaker, because his stock included candles), badger or grocer. It also had tailors, leatherworkers and cobblers, smiths, and lots of ale-sellers. These people tended to cluster in cottages on small plots either side of the road where the High Street was beginning to develop, referred to as 'Pinner street' in 1421. Perhaps this was convenient for selling at Pinner market, which surely met there. They would not have had shops, as we understand them, maybe selling from front rooms or workshops.

The number of brewers and ale-sellers is remarkable. In one year, 1386, forty-six people were fined for breaking regulations relating to brewing and ale-selling at a time when Pinner's population was probably under 600, including only one or two bakers. In 1388, Margaret Taillour was said to be selling ale inside her house (and fined for refusing to sell it to neighbours outside), and was one of several people apparently running proto-pubs.

All these people apart from the chandler (and possibly ale-sellers, if they bought from brewers) were selling things they themselves produced. All selling was highly regulated, but retailers – who bought from one person and sold to another – were particularly distrusted, suspected of cheating producer and customer alike.

There was a shop here (No. 58 High Street) from Elizabethan times.

This building of
c. 1500 was a baker's.

In the Elizabethan period and in the 1600s such basic traders still dominated. Retailers needed licences but there are hints that shops something like general stores were emerging. New traders had appeared, including mealmen, who sold grain and flour, as well as a weaver and – unexpectedly – a glover. A draper and a wheelwright are first recorded in the 1700s.

Predictably, trades often passed from father to son. Premises might be used for one particular trade over a very long period, especially if it required special facilities (like the baker's oven). Traders were quite often from yeoman families, fathers possibly setting younger sons up in a trade, funding training and initial outlay. It was common to combine trades, sometimes predictably, like the millers who were also mealmen. More surprising was the shoemaker who doubled as a grocer.

From the 1820s trade directories give a clearer idea of what could be bought where, while the first pictures of the High Street show some houses had the bay windows then fashionable for shops. Some trades appear for the first time: a coal merchant, a dressmaker, two straw-hat makers, a post office, a bookseller and stationer (who ten years later was a grocer). The odd combinations continued when there was a shoemaker who was also a pork-butcher and a grocer/draper.

Not all these people had shops, even in later centuries, and although most were based in the High Street, there were exceptions. For example the pork-butcher-cum-shoemaker was perhaps at Dears Farm, at the top of Bridge Street, which never became a shop.

Shopping Between the Coming of the Railways and the First World War

By the late 1800s the number and range of shops had greatly increased. Pinner's population was growing, the standard of living was rising for middle-class families and traders had easier access to London. In addition to several butchers, bakers, confectioners and grocers, there was a draper and milliner, an ironmonger, a florist and a dairyman. In addition, for the first time, shops began to open elsewhere in Pinner, mostly near the High Street, in Marsh Road and in the lower half of

No. 11 High Street housed father and son tailors both called James Bedford, 1820s–1912.

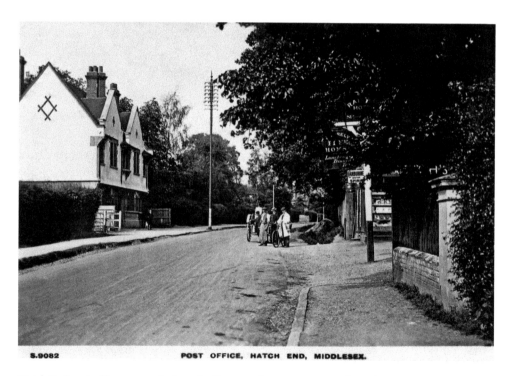

S.9082 POST OFFICE, HATCH END, MIDDLESEX.

Hatch End post office, *c.* 1912, before the first parade was constructed nearby.

Bridge Street. These included butchers, a fishmonger, newsagents and a clock repairer. (Some shops were on the land which is now Bridge Street Gardens.) Hatch End got the first national chain shop in Pinner when WHSmith, having lost their franchise at the station, opened a kiosk outside the nearby Railway Hotel in 1905/6. A post office (replacing earlier facilities at the station) and a bank opened opposite a few years later.

This extension of the shopping area continued. In Bridge Street, The Parade – the mock-Tudor shops around the corner of Love Lane and up Bridge Street – was built from around 1908. Small corner shops appeared at Pinner Green and at the Melrose Road/Kingsley Road junction by 1911.

Conspicuously absent are places where locals would eat out, but by 1900 there were several venues providing teas, meals and accommodation for visitors exploring the Middlesex countryside by train or bicycle. Around 1910 John How ran a fish-and-chip shop at the bottom of Bridge Street.

DID YOU KNOW?

Pinner once had a volunteer fire brigade, established c. 1882, replacing minimal earlier arrangements – buckets and poles for pulling apart burning thatch, stored in the church tower. The Beaumonts, wheelwrights at No. 27 High Street, were prominent throughout the brigade's existence. Initially it had a hand pump. In 1903, locals subscribed for a horse-drawn steam pump, with a tiny fire station in Bridge Street. By the 1930s the brigade had a motor fire engine but the amateurs' days were numbered. When North Harrow fire station opened in 1938 the volunteers stood down.

Some High Street Shops
No. 4 (The Victory) was probably built by Henry Whitberd (d. 1504), a miller and ale-seller. William Winter was baker there in 1548. There are hints the trade continued there until 1739, when a building at the rear was described as 'an old ... bakehouse'.

No. 7, the shop with a white wooden canopy over the pavement, was occupied in the early 1600s by Henry Dodds, apparently a grocer, and in 1669 by tailor William Read, followed by his son. Later it was a butcher's shop run by the Lees from the 1860s to the 1940s. (The canopy was to shade the meat.)

Nos 33–35 (Pizza Express) was occupied by George Webb in the early 1800s. He was a chandler, linen and woollen draper, and baker. His shop, which had bow windows, remained a bakery throughout the 1800s and an oven possibly installed before his death in 1835 is still there.

Nos 36-38 (Prezzo) was a very upmarket Edwardian grocer and off-licence, which advertised nine different kinds of cheese (including gorgonzola and camembert) and twelve whiskies.

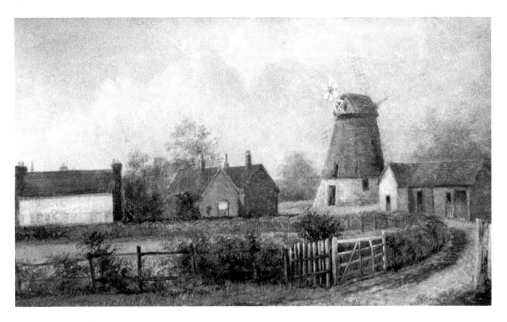

Pinner's last mill, painted *c.* 1870.

Millers

The first mill we know of in Pinner was a windmill, at Woodhall, in 1285, though there was probably a watermill somewhere earlier. Arrangements thereafter are uncertain, though two millers are recorded in the 1400s, until 1617 when a windmill was to be built on Pinner Common, near today's Caulfield Gardens, off Pinner Hill Road. This mill and its successor, or successors, met Pinner's needs until the last mill burned down in 1872. Curiously in 1787 this mill's owner also had a small watermill behind Love Lane (somewhere near the Pinn Medical Centre), which was out of action by 1828. Pinner's last millers were from the Jaques family.

Pubs

By the 1700s Pinner had around six pubs. They had names but these changed, and even swapped around, very confusingly. The longest established was today's Queen's Head, recorded as an unnamed tavern run by Margaret Bateman in 1636 (her family was there by 1633). It is recorded as The Crown in 1692, The Upper Queen's Head in 1742, and The Queen's Head in 1766. Meanwhile another inn had opened at the bottom of the High Street, which was first recorded in 1674 and later known variously as The Queen's Head (1714), The Lower Queen's Head (1735) and The Crown (1759). In the 1700s there was also an inn opposite the church.

There were other inns beyond the High Street, where a pub was often the first commercial venture to open: The Red Lion in Bridge Street from the 1720s/30s, The George in Marsh Road from the 1740s, The Bell at Pinner Green (1751) and a pub near Chantry Place in Hatch End (The Chequers *c.* 1747–63; the Sun 1767). From the mid-1700s, local breweries, based in Watford, Amersham and so on, were taking these over. After 1830, ratepayers who bought a licence could open beerhouses, producing a rash of new pubs. The Starling at Pinner Green, the Hand in Hand in the High Street, The Victory

The Queen's Head,
c. 1912, when licensee
Billows kept a bear.

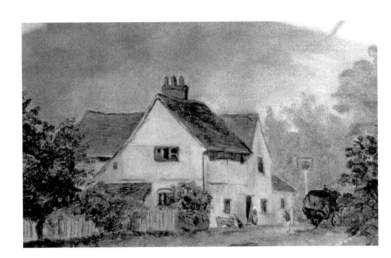

The first George,
shortly before
demolition for
the Metropolitan
Railway, 1884.

(originally a building fronting Marsh Road where the present Victory's garden is), The
White Hart (in the High Street in the building that lost part of its ground floor to provide
access to Sainsbury's), The Oddfellows and The Letchford Arms in Headstone Lane had
all appeared by 1869, as had The Railway Hotel near Hatch End station.

Victorians and Edwardians thought so many pubs encouraged drunkenness and began
attempts to reduce the number. The reduction continued as a result of social changes and
commercial pressures, and now only three old pubs – The Queen's Head, The Oddfellows
and The Starling – survive.

Planned Shopping Centres

In the 1920s and 1930s shopping in our area was transformed, with parades of shops
with flats above. These were developed piecemeal but rapidly on lines laid down by local
authorities' town-planning departments, usually to meet the needs of residents in the new
houses covering Pinner's fields.

The west side of Bridge Street now dates mostly from the 1930s. Planners required new buildings to be built much further back than the old line. Towards the top of the road, a new bakery was built behind the existing one, which continued to trade until its new premises were ready, when the old shop was demolished. On the east, the stretch between Love Lane and Waxwell Lane dates in part from between 1908 and the 1933, while right at the top is a building from before 1896, once the Oddfellows' stables. The lower parades date from the 1930s and 1960s. In Marsh Road, houses near the railway bridge were converted into shops around 1932.

In Hatch End Broadway, the first parade was on the station side, near the Old Post Office (now Pizza Express). North Harrow's shopping centre was well established by 1933. An early parade was 'The Broadwalk', on the western corner of the crossroads, and its name, like the vanished art deco cinema opposite, seems designed to confer a sense of glamour to the new area. Rayners Lane was slightly later, and its station, cinema and shops nearby were also deliberately stylish. In Marsh Road and at Hatch End, Rayners Lane and Pinner Green, service roads in front of some shops mark a short-lived period when planners required this.

Shops in these new parades were largely utilitarian, catering for the needs of local people. There were butchers, bakers, greengrocers, clothes shops, fishmongers, ironmongers, off-licences and more. This remained the case into the 1970s. Some shops were independently owned and sometimes short-lived. Often the function of a shop endured, though its owners changed. Some shops were parts of little local chains, with branches in nearby shopping areas, while others were national chains, like Boots,

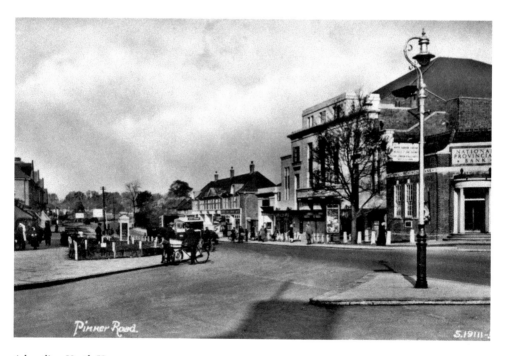

A bustling North Harrow, *c.* 1931.

Rayners Lane is distinguished by some iconic 1930s buildings.

Sainsburys, Woolworths and MacFisheries. Cinemas opened in our area in the 1930s, in striking buildings, at North Harrow and Rayners Lane, and in Bridge Street, where the ABC (later Langham) controversially replaced historic Dears Farm. There were still few restaurants, but cafés became widespread. In Pinner, the Old Oak Tearooms and the cinema café, with its Lloyd-loom chairs, are remembered with affection.

DID YOU KNOW?

During the Second World War, staples (food, clothing, etc.) were rationed. People had to get their rations from particular shops. Shop windows were boarded up to avoid bomb damage. The owners of the popular toy shop, Marchinis, at North Harrow, covered up their name, in case they were targeted as enemies. Fish and chip shops, cafés and British restaurants provided a respite from rationing. Dishes available at the café run by North Harrow's dairy now sound very unappealing – 'savoury toast' (baked beans on Spam) and cheese rissoles with mustard sauce.

Recent Changes

The last fifty years or so have seen the arrival of supermarkets, which replaced cinemas in Pinner and North Harrow, and were developed – quite sensitively in the face of local opposition – behind the High Street and at Hatch End. These transformed local shopping habits, so earlier shopping centres are now occupied largely by restaurants, coffee shops, and specialist and charity shops. Recent years have seen a trend back to smaller local grocers, run by the supermarket chains. Rayners Lane, distinguished by many independent shops catering for the daily needs of Asian and other ethnic minority families, is curiously the most traditional of our shopping centres.

7. Being Poor

Pinner's Workhouse

Pinner once had its own workhouse. It stood from 1790 where the railway embankment is now, behind the River Pinn as it passes through Bridge Street Gardens. A two-storey building, it was reached using a plank bridge over the river. It contained workrooms and rooms for the master of the workhouse, with outbuildings behind and vegetable gardens each side. It could accommodate thirty men, women and children.

Workhouses were intended to ensure those receiving relief were found work if capable of it, to discourage people from seeking relief and generally to save money. In practice, they often housed many elderly people unable to support themselves.

Pinner's workhouse rules were displayed on a board to encourage residents, and perhaps the master, to stay in line. There were to be three meals a day, based around bread and weak beer, served variously with gruel, soup, cheese or butter, with hot meat four times a week. Residents had to obey orders, work in the workhouse if unable to work outside and attend church. They might keep one penny (one-twelfth) of every shilling they earned. If they left the workhouse, they could take the clothes they wore there only with permission.

Capable residents might be found work locally, with a system requiring local employers (mainly farmers) to find work for them. Albert Pell, brought up at Pinner Hill House in the 1820s, remembered the apathy of the 'roundsmen' sent to his father; the Pells' predecessor employed them in a gravel pit, where an unwieldy barrow was the penalty

Pinner's former workhouse sketched *c*. 1884.

for arriving last. At the workhouse residents tended the garden, spun flax and picked oakum from old ropes to make new ones. Residents included children; in 1800 twelve pairs of breeches were ordered for men and four for boys. When Elizabeth Bedford died in childbirth in 1821 her older sons, William (eleven) and George (seven), went into the workhouse; two younger children stayed with their agricultural labourer father, and the baby was put out to nurse, though it soon died. Often, places in service would have been sought for girls and apprenticeships for boys. Pell also remembered his father's indignation about the 'village idiot', who spent his days chained to a railing along the side of the workhouse in all weathers.

After Pinner and other parishes were merged to form the Hendon Union in 1835, a huge workhouse was built at Edgware. The infirmary there became the place of care for Pinner's impoverished sick and dying. Pinner's workhouse became five small cottages, which survived until the railway was constructed.

The workhouse was just one episode in the long story of Pinner's poor.

Early Days

In the early days, many Pinner people were seriously poor. It is thought that in 1086 around half those with land in the manor of Harrow, which included Pinner, had so little they would have been at or below subsistence level if they had families but no other source of income. Things probably got worse over the next 250 years. Historians believe the population grew faster than the economy, so more were on the breadline, and that their poverty contributed to the dreadful death toll in 1300s' epidemics, above all the Black Death.

When we next get a glimpse of the Pinner community, in documents from the late 1300s onwards, it had become more complex. A smaller proportion of the villagers owned more of the land, so a larger, growing number had to earn their living from trade or craft, or by working for someone else. Their families would have been particularly vulnerable to disasters like illness or death of the main breadwinner. Nothing in surviving records reveals how such people fared. We must hope villagers supported the weakest, as small communities usually do. The fact that families were interrelated would have helped. There were no religious houses nearby to provide alms or care, and there is no sign Pinner's overlord, the Archbishop of Canterbury, did so.

Life under the Poor Act

Between around 1550 and 1600 the government developed, piecemeal, a system of poor relief. First they tried to meet the needs of the 'deserving' poor through voluntary donations. Parishes had to have poor boxes, with collections at church services; people with acknowledged needs were licensed to beg; and from 1552 every parish had to have overseers to collect donations and distribute them for the local poor. This proved inadequate, and from 1572 a poor rate could be levied on local landowners. The system was refined in the Poor Act 1601, which with modifications was the basis of poor relief until the mid-twentieth century. Throughout this time, the impression is of a deliberately harsh regime, designed to discourage dependency, implemented with occasional compassion.

In Pinner the overseers used their powers as little as possible. In the 1600s parish relief was a last resort probably available only to those without relatives able to help them. Charitable donations may have helped a little. Pinner had a poor box – it appeared in church inventories and was once stolen – but we do not know how much it yielded nor how that money was used. Local yeomen and gentry frequently left money for Pinner's poor. Legacies were rarely large, ranging from 1s to £20, and seem often to have resulted in one-off payments. In 1617, Richard Edlin stipulated that his bequest (£2) should be distributed at his funeral. Richard Clerk left £1 in 1610. His executors' list of recipients survives: thirty people, most probably elderly members of families with little or no land, got 8d each. This – worth less than £5 today – would have been of short-term benefit only. Some later legacies – for example £50 left by Christopher Clitherow's widow Mary Franklin in 1737 – were designed to provide a long-term fund (in that case, £2 a year for bread for poor people attending church). There must have been real hardship. Hearth tax returns show how many vulnerable people there were. In 1664, a quarter of Pinner households had only one hearth: these would have been the homes of labourers' families, or those even poorer, with no resources to handle misfortune.

Because people had to look after the local poor, they were hostile to newcomers who might need support. Harrow manor court repeatedly prohibited lodgers in the 1500s and in 1614 Francis Hawkins was threatened with a huge £10 fine unless he could prove his sub-tenant would not need parish support. This was a general problem, and from 1662 legislation set out rules governing when newcomers were or were not the responsibility of their parish of origin. From the 1600s to the 1800s Pinner overseers spent significant sums 'repatriating' the destitute.

Poorer villagers had wooden grave markers, like improbably old William Skenelsby's.

After 1750, and especially after 1785, the cost of relief escalated under twin pressures of wars with America and France (which disrupted trade) and bad harvests. The poor rate peaked in 1813/14 when parishes also had to support families of men in the militia. Agricultural wages, notoriously low and often seasonal, became inadequate as prices rose. It became common for areas to top up wages to meet the bare needs of men's families.

Relief was often given in kind, in the form of bread, for example, or clothing – particularly for children going into first jobs. Apprenticeships might be bought, or rent paid. Workhouses reduced but did not eliminate the need for outdoor relief. Harsh winters posed particular challenges. In 1799/1800 Pinner overseers decided those earning 10s or less should have their wages made up and receive two quartern loaves a week for each child (each roughly equivalent to two large loaves today). In addition, on twenty-one days that winter they arranged a soup kitchen, said to have fed 342 individuals – over half the village population. In 1827 overseers from Pinner and Ruislip parishes combined to create winter work for the unemployed lowering the top of Cuckoo Hill; the effect is visible today.

Living Poor in Victorian and Edwardian England

From around 1830 records give a better idea of people's lives. Pinner began in 1800s as a poor agricultural community. The population grew in fits and starts until around 1850, then started to snowball, largely because of the railways. Most households were still then involved in agriculture, though the proportion was falling as farms changed over to haymaking. The railways brought new employment, both on the railways and servicing commuter households as builders, gardeners, shopkeepers, laundresses and so on.

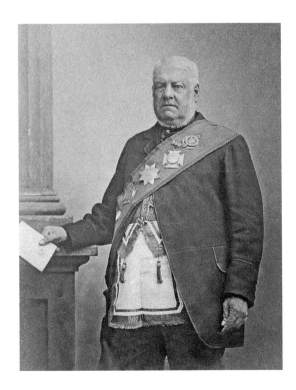

Pinner builder Thomas Ellement in regalia as Oddfellows officer, c. 1895.

DID YOU KNOW?

The Oddfellows Arms commemorates one of Pinner's many nineteenth-century self-help bodies. Benefit societies helped contributing members in illness or unemployment. The Independent Order of Oddfellows, Manchester Unity, established its Pinner branch in 1845. Their lodge was in Manchester Villas, which, like Unity Cottages and the pub nearby, are named after the society. Thrift clubs, like the coal club, encouraged saving for future needs, while 'slate clubs', hosted by Edwardian pubs, shared out at Christmas contributions not paid to sick members. Baptist and Methodist churches, which offered hope and solace to working-class families, promoted temperance.

Being a laundress was particularly useful to women who needed to support their families: in 1896 the vicar described it as a village industry. Affordable housing had long been in short supply, but until around 1860 what new housing there was comprised working-class cottages, made inexpensively using wood by local carpenters or, after around 1840, brick. Clusters of cottages like this grew up in Chapel Lane and Bridge Street, at Pinner Green and in Headstone Lane. By 1900, however, new houses were almost always for richer commuters. Increasingly Pinner's workmen travelled in from places like Wealdstone and Watford. Existing cottages were usually occupied by long-time Pinner families. Tramps sleeping rough or in barns were a familiar feature (some routinely spent their winters in the Hendon workhouse), while haymaking saw an influx of impoverished men from miles around.

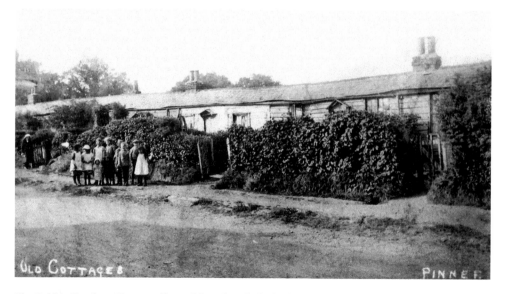

The Rabbit Hutches, Pinner Hill Road, long barely fit for habitation.

Tooke's Folly, Pinner Hill Road, once a farm building used by tramps.

Real Lives

Thomas Read was orphaned when his father, once coachman at Bentley Priory, committed suicide. He was ten when Harrow parish apprenticed him to John Hill, sweep of Pinner and Ruislip, in 1833 – a controversial choice. Sweeps had a reputation for cruelty to climbing boys, whom they sent up inside chimneys to clean them. This case worked out well. As a young man, Thomas returned to Pinner, married, set up his own chimney-sweeping business and raised nephew John Lively from boyhood. He was able to invest in building a pair of cottages at Pinner Green, named Caroline Cottages after his wife. When he died aged eighty-five, John succeeded to the business. Both were respected local Methodists.

The 1841 census recorded twenty-six people, agricultural workers and their dependants, living in barns on Pinner farms. One worker was a boy aged ten, apparently with his mother and grandmother. The Paradine family does not appear, though agricultural worker George Paradine was probably then living in a clay hut in the middle of Love Lane, near its junction with Waxwell Lane. He had built it himself using hurdles, furze and grass. His son, another George, was born there in 1835. The son described it as a squatter's hut, where they lived for years with no one claiming rent. The son later took part in the wars

in the Crimea, India and China, before returning to Pinner and working as a roadman. He lived at Unity Cottages in Waxwell Lane with his own sons and grandchildren. One grandson ('Nobby' Paradine) would later enthral local researchers with tales of poaching and hassling the suffragettes. Nobby's father was surely the postman for whom an appeal was launched in 1905 because he would be off work for three weeks, unable to walk, with no money from the club. Five of Nobby's seven siblings died in infancy.

Catherine Langthorn's family lived in Chapel Lane until 1884, in a cottage that lies under the railway embankment. Her letters to a son who emigrated to Australia reveal how precarious labourers' lives could be. Her husband and younger son worked variously on farms, on building the railway, and as gardeners, but, like her, both had serious health problems, which meant they had long periods unemployed. The parish covered doctor's costs, while the benefit and coal clubs and the money her son sent home afforded a little help.

Anne Rayner, of Rayners Lane, lost her agricultural labourer husband in 1861 and was herself unable to support her young family while caring for her daughter Susan, who had learning difficulties. Her husband's former employer launched an appeal for money to send Susan to an asylum in Surrey.

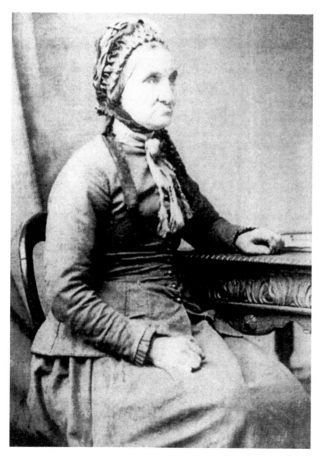

Catherine Langthorn (1833–91), who suffered from rheumatic fever, then untreatable.

8. The Middle Ages

Early Days

Pinner's beginnings are among its best-kept secrets. Pinner is first recorded in 1231 – after most English places, which often first appear in the Domesday Book (1086) – but we know it existed long before.

Pinner would have been heavily wooded in pre-history. Early finds, notably a scatter of Middle Stone Age flints, may indicate only passing visits. Pinner's oldest man-made structure is Grim's Dyke, probably constructed before the Romans came, to mark the

Grim's Dyke at Grim's Dyke Golf Course.

Pinna's 'Ora' (Nower Hill/Wakeham's Hill) from George V Avenue.

southern boundary of some forgotten territory north of our area. Iron Age pottery has been found in it. Very few Roman artefacts have been found in Pinner – none we can be sure were dropped there by someone living under Roman rule.

Pinner's first residents perhaps arrived in the enigmatic centuries after the Romans left. Pinner's name in early records was 'Pinnora', composed of 'Pinna' (someone's name) and 'ora' (a flat hill). The word 'ora' is also preserved in the name 'Nower' Hill. Experts tell us that 'ora' is unlikely in a place name dating after around AD 850, so by then Pinna and his people had probably settled here, near where the church is. Scraps of pottery found in Waxwell Lane may be from AD 700 or earlier.

Pinner was not mentioned in Domesday Book because it was part of the Archbishop of Canterbury's huge manor of Harrow, whose individual villages were not separately identified. Harrow had belonged to the archbishop since 824, when the royal house of Mercia transferred it to the archbishop to settle a long-running dispute. Pinner remained part of the manor for more than a thousand years, and its affairs were governed by the manor court at Harrow, where matters like inheritance and disputes between tenants were settled.

From surviving records of the manor court it has been possible to piece together a picture of what Pinner was like between around 1300 and 1500.

Pinner, *c.* 1300–1500

Pinner's centre was around the church and the emerging High Street. Near the centre most land belonged to head tenants, who held land directly from the lord. They had sizable estates including comfortable houses with several acres of land around them. East End Farm Cottage is a surviving example. Others were where Church Farm now is (at

East End Farm Cottage.

the top of the High Street), and at West House, where Pinner's Memorial Park occupies almost exactly the land once forming the medieval head tenement, Alveryches. Poorer villagers often lived in properties carved out of these head tenements. A cottage would be built on a small plot at the edge of a head tenant's property, its occupier paying rent to the head tenant. This is how the High Street grew up, piecemeal, gradually filling up with houses built on three different head tenancies.

Around the centre, especially to the west, north and south, land was occupied by the lord himself or his free tenants. The lord's land was run by officials for his benefit. Headstone and Woodhall (north of the Uxbridge Road) were farms; Pinner Park was a deer park.

The free tenants were Pinner's elite. They owed the lord rent, and had to attend the manor court, but were free to sell their land and leave the manor without needing the lord's permission like everyone else in Pinner. No medieval freeholder's house survives, though Pinner House in Church Lane marks the place of one and Letchford House, in Headstone Lane, another. Beyond the centre, people tended to live in small clusters of housing, for example at East End, West End, and – the most distant hamlet – in Hatch End, which developed in Headstone Lane, roughly opposite where Hatch End School is now, at the gate ('hatch') of Pinner Park.

To the north of Pinner lay the common and remaining woodland. Both were north of the Uxbridge Road, the common largely west of today's Pinner Hill Road and the woods further east. Villagers could put animals on the common, and in the autumn, pigs in the woods to fatten on acorns, in proportion to the land they owned.

Traces of open-field ridge and furrow in Pinner Village Gardens.

South of the village were open fields where villagers cultivated land. These occupied a vast area. They stretched from Marsh Road – where the land beside the Pinn was too marshy to cultivate – southwards beyond where Rayners Lane Station now is, taking in part of Roxbourne Park to the west and reaching beyond North Harrow Station to Pinner View on the east. The main fields were Down Field, west of today's Cannon Lane; Middle Field, between Cannon Lane and Rayners Lane; and Long Field, east of Rayners Lane. No one lived in this area; indeed, even when the open fields were converted into private farmland in the nineteenth century this part of Pinner remained almost uninhabited until developed in the 1930s.

Local people owned strips in these great fields, defined by ridges created during ploughing. One person's strips would be scattered in different fields, and the rich ended up with more than the poor. Key decisions – what to grow, when to plough, when to harvest – were taken communally, and fields ploughed with shared plough teams. Hay was grown on distant meadows, near where Village Way, Rayners Lane, is now and beyond.

Changes

The centuries between 1066 and 1500 saw huge changes. There were two major drivers of change in Pinner, one of which was population growth. The population increased rapidly until the early 1300s, so more cultivated land was needed. Pinner's open fields were extended at some point – one smaller field was called 'Newlands'. Elsewhere woodland was cleared for cultivation. Another reason for change was the archbishop improving his

estates, which would have involved heavy work by villagers, some of whom owed him labour services.

Clearing woodland made the lord's property more valuable. Woodhall (the name betrays its woodland origins) became a large estate (around 357 acres), which was probably cleared gradually between 1086 and 1285. Names of its fields memorialised the clearance. By 1285 one field was already known as 'Oldefeld', presumably the first cleared, while two others were 'Long Ridding' and 'Tan Rudinge', with 'ridding' (in its various forms) indicating a clearing of woodland. Pinner Park (first recorded in 1273) was probably created from previously uncleared land. Also cleared, in the course of the fourteenth and fifteenth centuries, was the area stretching north from what is now Hatch End Broadway. Until the early twentieth century, this was called 'Woodridings' – another 'ridding'. Near the Hertfordshire border, land was let to freeholders to clear and farm. One property would become the Pinner Hill estate.

Clearing woodland produced valuable timber. Archbishop Chichele used many trees for All Souls College, Oxford, which he founded in 1438. Its chapel has a hammer-beam roof with gilded angels and a beautiful set of misericords, all from the fifteenth century. Were they Pinner oaks?

Some changes were intended to benefit local people. Successive archbishops were presumably responsible for building Pinner church. Technically this was a chapel until 1766, because Pinner was part of the parish of Harrow. A chapel, almost certainly wooden, existed by the 1240s. It was rebuilt in stone, beginning in the thirteenth century. The new church was consecrated in 1321 and the tower added in the fifteenth century.

Pinner Park Farm, once a deer park, seen from Wakeham's Hill.

Pinner parish church (St John's). This shows the oldest part.

The archbishop also persuaded Edward III to grant Pinner the right to hold a market and two fairs each year in 1336, to enrich the village.

Another change benefitted the archbishop directly. In 1344, he bought back Headstone, which, though part of the manor of Harrow, had been held for decades by a freeholder. Thus he obtained a substantial house to use when in Middlesex. (His main residence was Lambeth Palace.)

In 1349, Pinner experienced the Black Death, when around a third of Britain's population died of bubonic plague. There are no records from this traumatic episode. The Peasants' Revolt of 1381 is believed to have been caused by high taxation for wars against France and by social upheaval resulting from the population crash. Rebels challenged high taxes, unfree labour and royal officials blamed for government policy. One of those killed was the king's chancellor, the Archbishop of Canterbury. Pinner people had good reason to resent the archbishop's lordship: court records contain many heavy fines imposed on people who, for example, allowed daughters to marry free men without permission. The main episodes in the revolt took place in London and the south-east, but some local people took advantage, breaking into Pinner Park, and some manor-court records may have been destroyed.

After the revolt was suppressed, the ruling class, including the new archbishop, reasserted control. When in December 1545 Archbishop Cranmer was obliged to surrender the manor of Harrow to Henry VIII, who promptly sold it to Sir Edward North, Sir Edward's new property of Pinner was still very much as described here.

Surviving Traces of Medieval Pinner

The Church of St John the Baptist, at the top of the High Street, is Pinner's oldest building. Its original ground plan, a simple cross shape, resembles that of Harrow Church. (No other medieval Middlesex church used this form.) The lower parts of walls on the north-east (left of the altar) are thought to date from the thirteenth century, while most of the rest of the original building is from the fourteenth century. The tower and entrance porch are fifteenth century. The flints used to build the church probably came from the 'marlpits' beside Waxwell Lane. The church was extended and restored later.

Headstone Manor, a splendid survivor, contains part of the 1310s building, with later additions. The surviving portion of the original great hall still has roof timbers blackened by the hall's open fire. The house is both the oldest surviving residence in Middlesex and the only place in Middlesex with a complete moat. The house recently opened to the public following restoration work. Conclusions from archaeological excavations in 2017, which uncovered the footings of demolished parts of the hall, as well as traces of a sizable earlier building – probably the oldest identified in Pinner – are eagerly awaited. Associated with the house is a great barn, built in 1505–06, the third oldest and second largest barn in Middlesex.

Pinner Park was created by 1273 to raise deer for eating or hunting elsewhere. It was itself too small for hunting. It occupied much the area of today's Pinner Park Farm. It was surrounded by a huge bank and ditch, parts of which survive and are a scheduled

Pinner parish church. The tower was added in the 1400s.

The Pinn, Pinner Park Farm, once dammed for a fishpond.

ancient monument. (They are not accessible to the public.) The park had gates near the village at Wakeham's Hill and on the opposite side of the park near Headstone Lane. These locations are now linked by a footpath, but there was no public access in the Middle Ages. (The A404, which bisects the park, is wholly new, from the 1930s.) The park keeper occupied a moated lodge between the present farmhouse and George V Avenue. The park also contained a fishpond, a valuable food resource in the Middle Ages, which is now a scheduled Ancient Monument. It was on the Pinn, and lay between George V Avenue and Moss Close. At the Moss Lane end there was a dam. At the other end of the pond was a sluice gate. When this was closed, the brook ran through channels on either side of the pond.

East End Farm Cottage, a head tenant's house of around the mid-1400s, is tiny in comparison to Headstone Manor, but it too was built with an open hall and has roof timbers blackened by the fire.

Ridge and furrow can just be discerned in Pinner Village Gardens and in Yeading Brook Open Space (both once part of Pinner's open fields).

Pinner Fair – the 'Charter Fair' – which closes Pinner's main roads on Wednesday after Whitsun bank holiday originated in the grant of 1336. It would originally have been a chance for people from Pinner and beyond to buy and sell goods of all sorts.

The basic road network around Pinner village emerged early. All the following are recorded before 1500, often with the name we use today: the High Street ('Pinner Street'), Uxbridge Road ('West Street'), Headstone Lane, Moss Lane, Love Lane, and Chapel Lane ('Baker Lane'). The Waxwell is first recorded in 1274. Several possible explanations have been given for the name, all of which would indicate Anglo-Saxon origins.

Right: Pinner Fair poster, 2016.

Below: Waxwell postcard,
c. 1905. The visible superstructure is
Victorian.

9. Famous People

Please note that many of Pinner's famous residents – Elton John, for example – appear in the chapter The Arts. Others have had to be omitted for reasons of space.

Connections to History

Every now and again someone has come to Pinner bringing with them echoes of historic events. One was Sir Bartholomew Shower (1658–1701), of Pinner Hill. He was a lawyer bound for great things, having supported some of James II's contentious policies, been knighted and made Recorder of London. His career never recovered after James was ousted in the 'Glorious Revolution of 1688 though he continued legal work until his sudden death.

John Zephaniah Holwell (1711–98), who lived briefly at Pinner Place and towards the end of his life at The Lodge (on the site of Elm Park Court), was a survivor of the 'Black Hole of Calcutta' (1756), when prisoners of war, many British, died confined overnight in a tiny room while held by the Nawab of Bengal. His account sparked outrage and is

John Zephaniah Holwell.

alleged to have facilitated the conquest of India. He was a surgeon and also wrote about smallpox inoculation in Bengal and Indian culture.

Horatia Nelson Ward (1801–81), the only surviving child of Lord Nelson and Lady Emma Hamilton, was originally passed off as their godchild and later 'adopted' by them. Horatia only realised she was Nelson's biological daughter in 1845, when his letters were published. After Nelson's death she lived with Emma in circumstances made increasingly difficult by Emma's debts, and, after Emma's death in 1815, with Nelson's sisters. Later she was happily married to a clergyman and had ten children, two dying in infancy. She moved to Pinner as a widow, living successively at West Lodge, at Elmdene in Church Lane and in today's Hatch End, in order to be near her son Nelson at West House. Her daughter Eleanor was tragically killed in 1872 by a horse bolting from the Queen's Head yard. Horatia is buried in Paines Lane Cemetery, where her tombstone originally described her, still, as Nelson's 'adopted' daughter.

Joachim von Ribbentrop (1893–1946), German Ambassador in 1936–38, had a house built on the new estate on Pinner Hill – Sans Souci (No. 99 South View Road), said to have featured a staircase of swastikas. He probably rarely stayed there but did visit the golf club. He was supposed to foster an Anglo-German alliance but his pride and lack of understanding, and frequent trips to Germany, did nothing to improve relations.

Brian 'Sandy' Lane (1917–42), who grew up in Barrowpoint Avenue, wrote *Spitfire!*, which was published in 1942 under a pseudonym and with many details masked. It has been republished, with clarifications, and is a rare first-hand account of life as a Spitfire pilot during the Battle of Britain. Lane was lost in action, probably shot down over the North Sea, in December 1942.

Brian Lane's book.

Distinguished in their Fields

John Tilbury (*c.* 1779–1860) was well known in nineteenth-century London. He was a coach builder, designer of the tilbury and a job master, who hired out horses and carriages, including hunters for gentlemen taking part in Society hunts. He also bred and trained horses including racehorses. For this purpose he acquired Dove Farm (on the site of Dove Park, opposite Hatch End station), where his elaborate facilities are said to have been visited by Napoleon III, seeking inspiration for his stables at Chantilly. John died at Dove Farm.

John Claudius Loudon (1783–1843), whose writings about gardening, agriculture and landscape design were influential in the 1800s, was at Woodhall Farm (rented by his father around 1807) when he was developing his ideas about improving farming techniques. He is responsible for the most unusual tomb in Pinner churchyard, which he designed for his parents. It resembles a concrete obelisk with a coffin protruding in mid-air. It has been believed, wrongly, that Loudon's father's body was thus buried above ground.

James Gairdner (1828–1912) worked at the Public Record Office and lived in Harrow Road. He edited many historical records, wrote histories of Richard III, Henry VII and Lollardy etc., and produced numerous articles on people of the 1400s and 1500s for the Dictionary of National Biography.

Isabella Beeton (1836–65) lived in what is now Hatch End Broadway from 1856 to 1863, the first years of her marriage to publisher Samuel. This period saw her contributing to his *Englishwoman's Domestic Magazine*, translating French serials, compiling the

Edwardian postcard featuring the Loudon tomb.

cookery column and from 1859 composing monthly supplements of recipes and advice on household management. The more organised Isabella was soon credited as editor, alongside Samuel, of a redesigned magazine featuring French fashions. They commuted together – very unusual then. Her *Book of Household Management* (1861), based on the monthly instalments, became a bible for Victorian housewives. Its recipes were drawn from published works and readers' letters, presented clearly, with ingredients listed first and costs estimated. The book also contained advice on topics like childcare and managing servants. Isabella was frequently pregnant and had several miscarriages. Her first son died at three months and her second, aged three, just after they left Pinner. She had two more boys before dying aged twenty-eight of puerperal fever.

Remarkably, Pinner was home to another Victorian celebrity cook Agnes Bertha Marshall (1855–1905), who also had a strong business partnership with her husband. She ran a cookery school in London, training cooks for domestic households, with an agency for servants. She gave public lectures and demonstrations, published a weekly magazine, and wrote cookery books. She popularised home ice-cream making. The couple sold cooking equipment, including ice-cream makers and brass moulds, branded with her name. Her success enabled this self-made couple to establish themselves in a Pinner mansion, The Towers.

Sir Ambrose Heal (1872–1959) is famous for Arts and Crafts furniture designs, stylishly simple in a reaction against Victorian taste, and for reviving the fortunes of the family firm in the Tottenham Court Road. The Fives Court in Moss Lane was designed for him by his architect cousin Cecil Brewer.

Fashion plate from *Englishwoman's Domestic Magazine*, 1862.

Left: Advertisement for Mrs Marshall's cookery school.

Below: Fives Court watercolour by Cecil Brewer.

Alfred Saunders (1899–1982), who later established a High Street photography shop, was official photographer and scientist to the *Discovery* expeditions to the Antarctic in 1924–39 and wrote *A Camera in Antarctica*.

Sir Patrick Moore (1923–2012), amateur astronomer, writer and television presenter, who was instantly recognisable and popular for his enthusiastic presentation and wearing a monocle, was born in Cannon Lane.

Sport

Before the First World War, The Chase was home to A. L. Bambridge (1861–1923), one of three brothers, sons of a royal photographer, who all played football for England in the 1880s. He later pursued a career as a portrait painter. He was often an official at local sporting events and in 1914 was prominent among those encouraging young men locally to volunteer. Another family of footballing brothers, the Gregorys, were developing their talents at much the same time. Their father farmed Pinnerwood Farm before becoming licensee at the Oddfellows. Frederick ('Fay') (1886–1937), Val (1888–1940), Allan (b. *c.* 1889) and Owen (b. *c.* 1891) Gregory were all at one stage contracted to Watford, with Fay and Val going on to play for the first team and Val to play for England. After Fay retired he became landlord of The Victory (then in Marsh Road). Unsurprisingly, Pinner teams did well during their youth.

Hilda Mary Light (1890–1967) was born and brought up in Woodridings (today's Hatch End). She, her mother and sister all played hockey for Pinner. She went on to play for Middlesex in 1909 and in 1924 captained Pinner, Middlesex and England. She was President of the All England Women's Hockey Association in 1931–47.

Cigarette cards of the footballing Gregory brothers.

DID YOU KNOW?

Two twentieth-century sporting fixtures brought celebrities to Pinner. In the 1930s, the Middlesex Farmers' Drag Hunt, based at Pinner Park Farm, followed trails often on Hall family farmland, at Pinner Park and Downs Farms. The Prince of Wales (the future Edward VIII) once took part. In the 1950s Father Caulfield of St Luke's organised donkey derbies. Famous jockeys Steve Donoghue and Gordon Richards were among those who gamely competed.

Gary Player (b. 1935) spent two months in Evelyn Drive in 1956, living with a friend at the friend's uncle's house between tournaments. During that time he practised at Pinner Hill, equalled the course record and took part in a charity match.

Derek Bell was born here in 1941. He is best known for winning the Le Mans twenty-four-hour race five times in the 1970s and 1980s, but also had several wins at Daytona and raced in Formula One. In 1970, he took part in filming *Le Mans*, starring Steve McQueen.

Wartime postcard of Rota the Pinner lion.

Mark Ramprakash (b. 1969) lived near Hatch End and attended Grimsdyke School. His first club was Bessborough Cricket Club, Headstone Lane. He had an exceptionally successful career in county cricket, played often for England and has since been engaged in coaching.

Snooker player Martin Gould (b. 1981), who won the 2016 German Masters, hails from Pinner – 'The Pinner Potter'.

Boxers John Conteh (b. 1951) and Audley Harrison (b. 1971) have both lived locally.

DID YOU KNOW?

One famous Pinnerite was a lion, Rota, who lived in a cage in a Cuckoo Hill garden after being won as a cub by the managing director of Rotaprint. Despite neighbours' reservations, an inspector confirmed in 1939 that there was no real likelihood of his escaping during bombing. Meat rationing was a bigger problem. In 1940, he was transferred to London Zoo and later given to Sir Winston Churchill – newspapers carried photographs of Churchill feeding him. Rota fathered twenty-four cubs at the zoo, so life there was probably better.

Politics

Tom Driberg (1905–76), who lived briefly at No. 66 Waxwell Lane, must be one of Pinner's most complex residents ever: a communist who made his living writing a society column for *The Daily Express*, a high church Anglican and eventually a life peer after years as a Labour MP. Since his death it has also been suggested he may have been recruited by MI5 to spy on the Communist Party and then acted as a double agent for the Soviet Union.

Labour politician Merlyn Rees (1920–2006) was both pupil and teacher at Harrow Weald. He lived in Hatch End and stood for Harrow East unsuccessfully, before entering parliament in 1963 for Leeds South. His ministerial offices included Home Secretary in 1976–79.

Rhodes Boyson (1935–2012), Mrs Thatcher's eccentric and controversial minister, lived in Paines Lane.

Daniel Finkelstein (b. 1962), adviser to Conservative politicians, is a less divisive figure, which is fortunate since he was raised to the House of Lords as Baron Finkelstein of Pinner, the only peer ever to have had Pinner as part of their official title.

10. Grand Houses

Pinner's Timber-Framed Houses

Until the mid-1600s, every building in Pinner except the church would have been built using wood. Good houses had a timber frame, resting on flints, and filled in with woven lathes (like wicker-work) coated in daub – a mixture of clay, dung and animal hair. The surviving ones are Pinner's treasures.

Medieval Pinner had one grand house, Headstone Manor. Tree-ring dating suggests it was built around 1310, probably by the Ramesey family. In 1332, it was acquired by Edward III's Chancellor of the Exchequer, Robert de Wodehouse. Archbishop John Stratford bought Headstone from Robert in 1344 and archbishops stayed there occasionally during the next hundred years. Otherwise the best houses belonged to free and head tenants (yeomen), who held sizable properties directly from the archbishop. The oldest to survive is East End Farm Cottage, built about a century and a half after Headstone. Though of very different sizes, both houses had the same basic structure. Most of the building was a hall, open to a high roof, containing an open fire. At one end, a section divided off (in a cross wing at Headstone) had two storeys, forming small unheated rooms offering some privacy. At Headstone, only the cross wing and part of the hall remain.

Bits of houses roughly as old as the cottage survive in the High Street, including The Victory (No. 4). This was just the side wing of a building facing Marsh Road, which was then wider. The slope makes the flint base particularly obvious. It belonged to Henry Whitberd, miller, ale-seller and owner of several cottages. There would also have been good houses on the archbishop's properties at Woodhall (hence the name) and at Pinner Park, where a 1634 map shows a moated house, probably once the park keeper's.

The footings of Headstone's early buildings uncovered 2017.

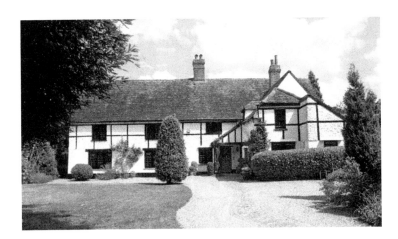

Sweetmans Hall, a sixteenth-century yeoman's house.

By the 1500s houses were being built with smoke bays, where part of the building was separated off to form a kind of primitive chimney. Elsewhere the houses had two storeys. This was how Sweetmans Hall (West End Lane), the Manor House (Waxwell Lane), and probably Church Farm (High Street) began. Later still houses were built with proper chimney stacks, as at Waxwell Farm and Letchford Houses (Headstone Lane). Affluent villagers' houses like this would have had a yard with outbuildings. Smaller houses were beside the road, as at Orchard Cottage and Bee Cottage (Waxwell Lane). Many similar houses have gone. Dears Farm in Bridge Street (demolished in 1935) was expensively decorated with 'close-studding' – timbers fitted very closely together.

Existing houses were modernised to keep up. East End Farm Cottage, for example, was first converted into a two-storey building with a smoke bay around 1570, and a few decades later an external brick chimney stack was added. The owners also commissioned a wall painting, and the surviving fragment reveals quality exceptional for a small house. Headstone too was altered in the late 1500s and other houses had chimney stacks added.

An 'Upper' Class Emerges

By 1600 much had changed. In 1545, the archbishop surrendered Harrow (including Pinner) to Henry VIII, who promptly sold it to Sir Edward (later Lord) North, a royal official responsible for property confiscated during the Dissolution of the Monasteries. Lord North and his descendants, like the archbishop, were distant overlords, valuing the manor for the money it produced. Pinner saw no sudden change but the manorial system's grip was weakening. Prosperous villagers were freer than their forebears and could aspire to a cultured lifestyle. Meanwhile wealthy London merchants wanted to invest in land near London. All these changes affected Pinner.

In the 1660s Charles II's impoverished government introduced a 'hearth tax' on fireplaces (a rough indication of wealth). Four Pinner houses were then much grander than the rest. In 1672 Pinner Hill House, Canons, Headstone Manor and Woodhall had between ten and fourteen hearths. No other had more than seven, and the vast majority had between one and four. The occupiers of the three largest were the only people in Pinner dignified with the term 'Esquire', denoting gentlemen of property. Only Headstone survives.

Canons (near Cannon Lane) was a village success story. The Reading family were head tenants, and from around 1400 they also rented Headstone. In 1547, Richard Reading held four head tenements including Canons and leased Headstone from Lord North. The Readings were the first Pinner family to live like gentlemen: three went to university in the 1570s, and improvements at Canons included a dovecot – a status-symbol requiring a licence. In 1606, however, the family sold it. By 1682 it was the country residence of Sir Edward Waldo, a prominent London merchant. In 1728, Edward's daughter Grace, Lady Hunsdon, financed a better bridge in Cannon Lane. A memorial plaque on today's bridge is the last reminder of this great house.

Headstone and Woodhall were sold by Lord North around 1630. Headstone was bought by the tenant, Lord North's steward, whose sons sold it in 1649 to London merchant William Williams, who probably built a big new wing, which forms about a quarter of the house today. From him it passed to other London merchants, and thereafter was usually an investment property, rented out. Woodhall too was bought by a Londoner and usually rented. A tiny drawing on a 1638 map suggests it was already quite substantial: part survives as a wing of today's farmhouse.

Pinner Hill House, by contrast, was a wholly new building. Christopher Clitherow, another London merchant, built his country residence on land bought in 1617. He must usually have been at his London house as he held important offices in the City including being Lord Mayor (1635). Members of his family married into local families – the Edlins of Pinner and the Hawtreys of Ruislip. His son and namesake was another merchant.

Memorial in Pinner church to Christopher Clitherow III (d. 1685).

When he died suddenly in 1654 his draft will was in a box in his study at Pinner (the key was in his wine cabinet) but his wife's draft marriage settlement was in his London lodgings. His sons were infants then and both died childless in their thirties. The widow of the younger, another Christopher, sold the property to Sir Bartholomew Shower, a notorious young judge. The Clitherows and Shower are buried in Pinner, with memorials at the church. The brick footings of their house are under the golf course at Pinner Hill, in front of the present mansion, but we have no idea what their house, the grandest then in Pinner, looked like.

Other houses would have seemed luxurious to contemporaries, including The Grove, home of the Edlins, an old Pinner family. Their house was replaced later, so we know only that it had five hearths, although items embroidered by a daughter around 1670 suggest real refinement. This family also illustrates Pinner's integration into a changing world: in the 1600s two generations sent boys to Cambridge. One younger son, apprenticed in youth to a Harrow tallow chandler (candlemaker), became Master of the Tallow Chandlers Company in the City. During the Fire of London he sent the company's valuables to Pinner – presumably to his brother's Grove – for safekeeping.

1700–1845
Over the next 150 years, more outsiders acquired Pinner properties: London merchants, lawyers, military officers and other 'gentlemen', some titled junior members of grand families. Some were investors, renting houses to others; some were here occasionally; and others were long-term residents. Houses were built or improved for them.

Eighteenth-century Pinner Hill House, depicted c. 1850.

DID YOU KNOW?

Albert Pell (b. 1820) wrote of his boyhood at Pinner Hill House. The house was isolated, 'so the family blunderbuss was fired at night about once a fortnight, to announce that the household was armed' and notices in the woods warned evildoers of man-traps. His father's friend Wilberforce, the anti-slavery campaigner, stayed with them: 'I felt a giant was in the room.' He remembered the views, bird-nesting, wild daffodils, seeing St Alban's Abbey from a great oak, and, in 1834, watching parliament burning from the hilltop garden.

The grandest was still Pinner Hill House. One resident was Lady Jane Brydges. Her father, who died weeks before her birth, had been heir to the 1st Duke of Chandos, who built a fabulous mansion, Canons, near Stanmore before losing his fortune through the South Sea Bubble. The 2nd Duke had to demolish Canons in 1747, replacing it with a comparatively modest building (now North London Collegiate School). Despite this, the family provided Lady Jane with the Pinner estate when she married her cousin James Brydges. Here they lived quietly until Jane died, childless, in 1776, followed by James in 1789, losing his chance to succeed the 3rd Duke, the last of his line. Perhaps they had that status symbol of eighteenth-century aristocracy, black servants, for in 1781 two people were buried at Pinner: Jeremiah Blissard 'a negro' in March and Phillis Blissard 'a negro woman' in October. Nothing more is known of them, but they were probably servants in a local aristocratic household. The house was then bought by James Forbes, of the East India Company, who may have had the house rebuilt – the present house appears to have been originally in the style of the late 1700s. Later owners were lawyers. John Baker Sellon (owner in 1803–22) probably added the Regency bay and turret; Albert Pell, a judge with reformist sympathies, replaced him.

The Hall was a new mansion, built c. 1730 by John Gibson, a London jeweller who married Bartholomew Shower's niece and heir. In the 1770s it was rented by Lady Henry Beauclerc, widow of a grandson of Charles II and Nell Gwynn. In 1779, Francis Legge followed her. He had been governor of Nova Scotia in 1772–76, but was recalled because his uncompromising attitude alienated powerful men there, a matter of concern during the American Revolution.

Meanwhile the Beauclercs' daughter Mary married the local vicar, Walter Williams, and in 1788 they moved into Pinner House. This delightful building in Church Lane, from the early 1700s, was enhanced by them by re-routing the road that originally crossed what is now the front lawn, so it passed instead over their land on the other side of the road. This was the main road to London, and the turnpike trustees were indignant.

The Edlins' former properties, The Grove and Pinner Place, had passed to sisters Hannah and Martha. Both were significantly remodelled in the 1700s, and were generally let to gentlemen. West House too was rebuilt, in the early 1800s, becoming for the first time a gentleman's residence.

Pinner House. A great-granddaughter of Charles II lived here.

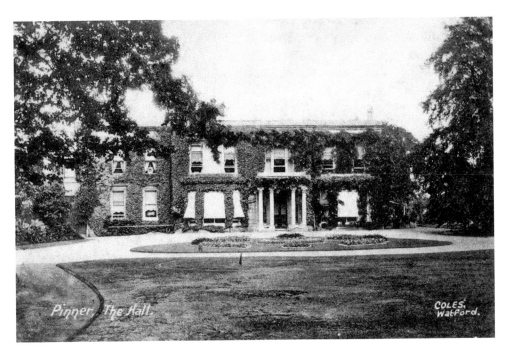

The Hall, off Uxbridge Road, in its heyday.

The Impact of the Railways

Railways enabled men with regular business in London to occupy country houses. Except close to a station, this was possible only if you could afford a carriage. After Hatch End station opened (1842), this became a select area studded with homes of London businessmen and the like – 'carriage folk', very grand by local standards. Houses around Pinner were given makeovers by new owners, and new houses built.

Few survive, Waxwell Farm, Pinner Hill House and part of West House being the only ones. A lodge or road name may commemorate a house or owner, but most have left nothing to show how numerous they were. Here are some and some occupiers: Barrowpoint House (QC William Barber), Woodhall Towers (head of the soap firm D. & R. Gibbs), The Hall (Nugent, head of a discount company), Old and New Dove House (retired stock broker A. J. S. Eck was at New Dove House), Clonard (Skilbeck, of dye merchants Skilbecks Drysalters), Oxhey Grove (QC Henry Rowland Brown), Nower Hill (Ambrose Heal, head of the furniture firm), East House (Thomas Forbes, head of a major insurance firm), The Grove (Queen Victoria's photographer John Mayall, then railway contractor Francis Rummens), Pinner Place (James Mortimer Garrard, head of the jewellers), The Towers (celebrity cook Agnes Marshall and her husband), West House (widowed Frances Dickson and family, including average adjuster son-in-law J. S. Hogg), Waxwell Farm

Woodhall Towers, a bizarre mansion built by Arthur Tooke.

(the Trotters – the managing director of Dewhursts cotton manufacturers and the boss's daughter), Antoneys (Frank Ree, general manager of the London & North-Western Railway Co.), and Pinner Hill House (solicitor A. W. Tooke, his son and daughter, and after 1903 Lammas Dore, head of a metal trading company).

Pinner Hill House and The Hall were the largest. The others ranged imperceptibly into more ordinary large houses that also multiplied after Pinner station opened. Usually the breadwinner was at the peak of his career, so young families were rare; the house was usually sold when he died or moved away. Occupiers enjoyed a gracious lifestyle. In 1911, West House contained six servants, with a coachman and a gardener living in estate cottages with their families. Pinner Hill House had six servants, plus a chauffeur, two grooms and two gardeners. At Old Dove House, occupied by someone who traded with the Far East, all five servants were Japanese. These houses had large estates with elaborate gardens, perhaps with a lake and an island. There were greenhouses, kitchen gardens, tennis courts, croquet lawns, stables, lodges, gardeners' cottages, fields for the essential horses and sometimes a 'farmery' with a few cows, chickens, and so on.

These households influenced local life. Men were magistrates, councillors and churchwardens, and families supported efforts to improve local conditions, for example founding the Cocoa Tree temperance tavern, the local voluntary fire brigade and the scheme providing a parish nurse, who treated the needy without charge.

Grand house culture here probably peaked in around 1900. The opening of the Metropolitan station in 1885 gave a brief boost to grand houses – Waxwell Farm, Nower Hill and The Towers were all upgraded after 1885. However, a station in the heart of the village opened it up to less wealthy people and development began to escalate.

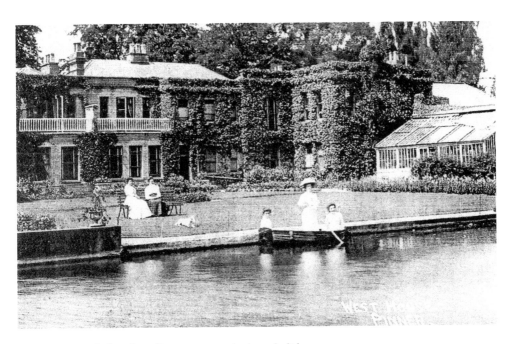

West House with the Edwardian servants enjoying a holiday.

The hall, Pinner Place, c. 1900.

Houses near the station were affected first. By 1900 there were plans to build on parts of the Barrowpoint estate, while the owners of The Grove and Pinner Place were anticipating development on their land. Garrard's son sold up in 1906. The advert offered Pinner Place as 'A Tempting Land Speculation ... ripe for development ... a picturesque old-fashioned residence and grounds ... 26 acres ... suited to subdivision for building purposes'.

The purchaser A. W. Marshall soon had West End Avenue and Meadow Road rising on what had been Garrard's land. By the 1930s, though surviving Edwardian owners still occupied some grand houses, many had entered a sad twilight, their lands developed round them while they decayed, awaiting new uses that rarely materialised.

11. Suffragettes

The Local WSPU Branch

During the Votes for Women campaign, Pinner was unusual, for a small place, in boasting a branch of Mrs Pankhurst's Women's Social and Political Union (WSPU) – the militant suffragettes. Its members took part in suffrage demonstrations in London, two were imprisoned for militant actions (one becoming a hunger striker) and the branch triggered a 'riot' in the centre of Pinner. The branch owed its existence to women from Paines Lane.

The branch's first secretary was Janie Terrero, then around fifty-two. She said she had supported female suffrage since she was eighteen. Her husband, Manuel, was an Associate of the Royal School of Mines and grandson of an Argentinian general who lived in exile in Southampton. They were childless. Janie hosted meetings for another suffrage society in 1905 and 1907 when they lived in Southampton and became a member of the WSPU in 1908. They moved into Rockstone House, Pinner, around 1909.

Their neighbours included the McClellands. Epsey McClelland, a widow, was a Yorkshire lawyer's daughter. She and two sisters had long been involved with the campaign for women's rights, particularly efforts to broaden employment choices for women. They had careers in the decorative arts including interior design, and Epsey and her daughter Elspeth were working in London when they came to Pinner. Elspeth followed in the sisters' footsteps, becoming the first woman to take a building course at London's Polytechnic, so she could supervise alterations incidental to decorative schemes. She designed cottages and would later describe herself, controversially, as the first woman to work as an architect. Recently she had been a paid WSPU organiser, promoting new branches at Croydon and Marylebone and regularly acting as a speaker.

The Verdens, also neighbours, had a unique role in the Pinner group. Marie's husband was partner in a Tottenham Court Road furnishing firm. They had seven children, aged

Neal's Ing, Paines Lane, built for the McClellands.

Marie Verden, *c.* 1891, with (from left to right) Edna, Phyllis, Oscar and John.

in 1910 between eleven and twenty-six. Marie, three daughters and one son became regular WSPU speakers. Marie, from a theatrical family, had lived with her stepmother, Madeleine Lucette Ryley, playwright, suffrage campaigner, and vice-president of the Actresses Franchise League. In October 1909 'the North-West London WSPU' was established in Kilburn. It was intended to cover the Harrow constituency, including Pinner. The constituency was huge, with the largest population of any in the country because London suburbs had expanded so. The branch's main focus was around Kilburn, then much more developed. Elspeth McClelland occasionally spoke for them from January 1910. Early WSPU activities in Pinner were under their auspices with Pinner women the driving force.

In March 1910 Mrs Penn Gaskell (secretary of North-West London WSPU) chaired a meeting at the Cosy Corner Tea Rooms in Bridge Street (No. 26). Marie Verden later recalled limited interest, despite speakers including Lady Emily Lutyens, wife of the architect and sister of Lady Constance Lytton, a famous WSPU activist. Two weeks later a meeting at the Terreros' was more successful, with new members joining. Elspeth McClelland organised a series of meetings outside the tiny fire station at the corner of Love Lane and Bridge Street. She herself addressed around fifty people there in April 1910 and other speakers followed. The Pinner WSPU banner was unfurled that October.

Pinner WSPU was formally established in February 1911 at the Terreros', in the presence of Mrs Drummond, a leading WSPU organiser. Janie, Elspeth, Marie and Marie's eldest

The Pinner WSPU banner, made by the McClellands, with repairs.

daughter Edna, were the first officers, along with an unidentified Miss Bessie Barrett. The branch remained active up to the start of the First World War.

Activities in Pinner

In Pinner, suffrage campaigning consisted largely of activities to encourage support for the cause and fundraising. There were public meetings outside the fire station on Saturday evenings. Members were urged to support speakers, who had to contend with heckling. Some speakers were local women but they also included visiting suffragettes. The most eminent was Mrs Drummond, who talked about women's wages to a 'crowded' meeting.

There were indoor meetings, at the Cosy Corner, at the Cocoa Tree at the top of Pinner High Street, and for a few months in 1913/14 in a shop in the High Street then run by the branch. There were At Homes and drawing room meetings in members' houses, with non-members encouraged. There were garden meetings, fêtes and bazaars. All featured visiting suffrage activists including Lady Constance Lytton, Madeleine Lucette Ryley and Mrs Pankhurst's brother. Membership seems to have reached around eighty, though some meetings were attended by many more. People we know got involved included Mrs Emery, wife of the High Street photographer, and Miss Conder, headmistress of St Mildred's in Avenue Road (attended by Molly Verden). Membership probably declined as the WSPU's tactics became more radical.

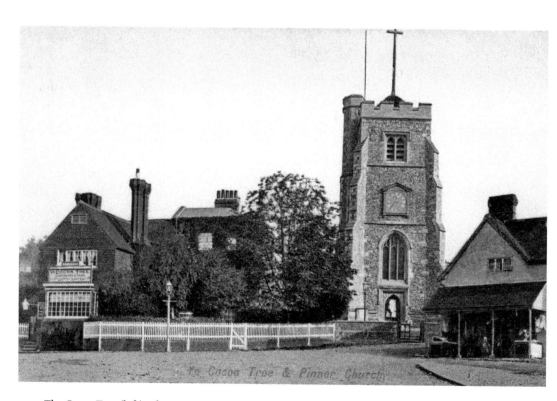

The Cocoa Tree (left), where some WSPU events took place.

Members sold the WSPU magazine, wrote to local papers and engaged in minor activism. In 1911, they put on an anti-suffrage play. (The Verdens and Elspeth McClelland had experience in local amateur theatricals.) They raised money for the local branch and for the central organisation. They sold items sewn at a regular working party and things like homemade cakes and jam. The branch's collection was presented in a purse, sometimes at great Albert Hall meetings: in summer of 1912 about thirty people contributed, and in December 1913, about twenty.

There was some difficulty filling offices that fell vacant. Both Bessie Barrett and Elspeth McClelland left Pinner in 1912, for example. Women did take on the responsibility, however, and the branch maintained a busy programme up to 1914. Elspeth's post as speaker's organiser passed to Edith Heal, wife of furniture designer Ambrose. She had been an art student at the Slade, like many campaigners. She also took on Janie Terrero's role when she was in prison. Marie Verden remained an officer throughout the branch's existence and by 1914 was secretary and organiser. Her second daughter Phyllis was secretary for part of 1913. Other officers included Mrs Muller of Meadow Road (secretary after Phyllis) and Miss E. M. Wadeson, from Hatch End.

Involvement in the National Campaign

Some Pinner members became more deeply involved. The WSPU encouraged members to boycott the 1911 census (just after the Pinner branch was established). No one then a Pinner officer appears in it. The return for Rockstone House records only Manuel – not Janie or any servant. Elspeth went to the trouble of obtaining a form as if she and her mother lived in separate households, then refused to complete it. None of the adult Verdens appear at all, nor does Bessie Barrett.

The secretary would attend weekly meetings of branch secretaries and gatherings in London where campaigns were planned. In July 1912, for example, Janie Terrero (just out of prison) was 'in her old place, on the platform at the usual meeting of the Women's Social and Political Union, at the Pavilion Piccadilly Circus'. Meetings could be eventful. WSPU leaders might appear while on release from prison on licence. They had taken part in hunger strikes, demanding to be treated as political prisoners. When too weak for further force-feeding, they were released until they recovered, then rearrested. In July 1913, Mrs Pankhurst was rearrested from the platform at the Pavilion. WSPU members tried to prevent this. Mrs Verden later appeared in court as witness for a Miss Rogers, accused of striking a policeman. Marie confirmed Miss Rogers' account that the policeman had made 'a most brutal assault on a woman'.

Pinner women also took part in various processions. In June 1911 a contingent marched behind the Pinner banner through the West End to the Albert Hall and in July 1912 several Pinner members including Mrs Terrero (released from prison two weeks earlier) took part in a big demonstration in Hyde Park, when Mrs Verden was said to have led 'a band of 50 strong through the Grosvenor Gate'. They also took part in a huge meeting in Gladstone Park, organised by the North-West London WSPU in June 1912.

Some Pinner women took part in more controversial actions. In February 1912, Mrs Terrero sought volunteers for a planned deputation to Parliament. The government had recently thwarted the Conciliation Bill, which would have given some women the vote,

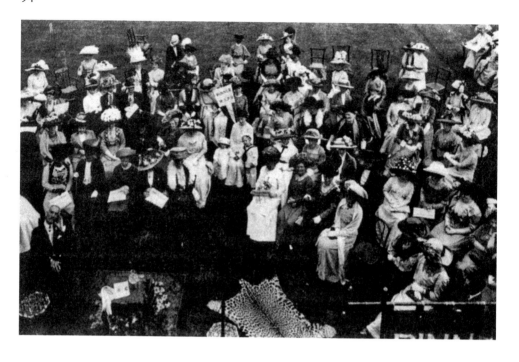

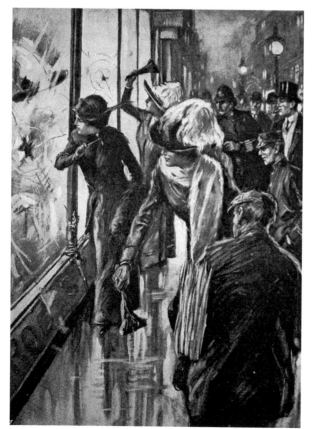

Above: WSPU meeting at Rockstone House featuring Lady Constance Lytton.

Left: Suffragettes smashing West End windows, March 1912.

and was refusing to negotiate an alternative route to votes for women. WSPU members began co-ordinated smashing of windows throughout the West End on 1 and 4 March.

Two Pinner members were arrested. One was 'Mabel de Roxe', alias Mabel Roxburgh Wilkinson, a woman separated from her husband; in 1911 he was living alone, their two teenage daughters were at boarding-school, and Mabel was in Meadow Road, Pinner. She described herself as a 'widow', teaching art at home, with a three-year-old son and lodgers. As a separated woman Mabel may have had a particular interest in women's rights.

Mabel broke windows in The Strand. She was one of the first window smashers in court, perhaps because the evidence against her was unusually straightforward. She had been caught by an errand boy and arrested by a police constable who saw her with a hammer. When charged at Bow Street she said 'I did not think I had broken so many'.

Mabel spent four months in Aylesbury Prison. She was among the first released and so in the small group ceremonially greeted at Marylebone station. They were met by a crowd of suffragettes wearing the WSPU colours of purple, white, and green and carrying matching flowers, marshalled into two lines:

> A great burst of cheering went up, as they walked down the lines, greeted as they came, covered with flowers, receiving a welcome such as any victorious General would be proud to receive on his return home from the war.

Also arrested on 1 March but sentenced later, Janie Terrero had smashed a window in Oxford Street. She had told a Pinner meeting that she hoped to be arrested. She explained afterwards that she had been converted to militancy by the events of 'Black Friday', when, in November 1910, members of a deputation to parliament were attacked and injured by a mob that WSPU members believed included plain-clothes policemen. Janie had offered hospitality at her home to three women recovering from injuries.

She was sentenced to four months' imprisonment. While in Holloway, Janie took part in two hunger strikes and was force-fed. Janie's second hunger strike damaged her health so she was released early. In the next weeks she appeared at meetings recounting her prison experiences but, although she briefly resumed her role as secretary, she reduced her involvement in the WSPU on her doctor's advice. She was clearly proud of her actions, and she was photographed wearing the medals awarded to WSPU prisoners and hunger strikers.

Mrs Verden was interviewed in June 1914 when recovering from injuries sustained in a recent deputation, from which she had returned on an ambulance. She must therefore have been in the deputation to Buckingham Palace on 21 May 1914, ostensibly an attempt to petition the king. The WSPU claimed police, present in overwhelming numbers, employed 'disgraceful violence'. Some sixty-seven women were arrested. It was the last major act of militancy in the WSPU campaign, suspended at the start of the First World War. In Pinner there would be one more major event.

The Pinner Riot

Heckling had always characterised outdoor meetings. By 1914 WSPU tactics were very controversial, involving much destruction including – one tiny local example – burning down the new station at Croxley Green, and hostility seems to have become worse.

'Nobby' Paradine, who lived in Unity Cottages opposite the police station, recalled being sent as a boy by the uncle who lived with them – the local gravedigger – to get flour and eggs from Gurney's store (Nos 36–38 High Street) to be thrown at the suffragettes. The police sergeant would tease the uncle about his plans for the following Saturday.

In June 1914 a speaker outside Pinner fire station was set upon by a crowd. She was Miss Rogers from WSPU HQ, John Verden's fiancée, the woman for whom Mrs Verden had acted as witness. Mrs Verden blamed 'hooligans' from Harrow, egged on by local publicans and tradesmen, for ensuing events, described in local papers as a riot involving several hundred people. A fracas started when John Verden tried to eject a drunken heckler. Miss Rogers was knocked from the chair from which she was speaking and was with difficulty escorted by police to a passing bus, the sergeant getting hit by a bag of flour. Then the crowd, said to be 400 strong, followed the bus into Paines Lane, where windows were broken at the Verdens' and the Terreros' houses. No one was prosecuted.

Bridge Street. Suffragettes spoke outside the fire station (beyond The Red Lion).

DID YOU KNOW?

The Museum of London has items that belonged to Janie Terrero including her photograph and a handkerchief she embroidered in Holloway Prison with the signatures of fellow hunger strikers.